A–Z

OF

EALING

PLACES - PEOPLE - HISTORY

Andy Bull

AMBERLEY

First published 2022

Amberley Publishing
The Hill, Stroud, Gloucestershire, GL5 4EP
www.amberley-books.com

Copyright © Andy Bull, 2022

The right of Andy Bull to be identified as the
Author of this work has been asserted in
accordance with the Copyrights, Designs and
Patents Act 1988.

ISBN 978 1 3981 1065 6 (print)
ISBN 978 1 3981 1066 3 (ebook)

British Library Cataloguing in Publication Data.
A catalogue record for this book is available
from the British Library.

Typesetting by SJmagic DESIGN SERVICES,
India. Printed in Great Britain.

Contents

Introduction

Ealing is best known as the 'Queen of the Suburbs', but there is far more to its rich history than that. *A–Z of Ealing* tells the fascinating story of the London borough and its seven constituent towns – Acton, Ealing, Greenford, Hanwell, Northolt, Perivale and Southall – through nuggets about its remarkable people and places.

I have lived in Ealing for nearly forty years, but am still learning new things about my home town. Among the things I discovered as I researched this book are that the soft toy which inspired A. A. Milne to write *Winnie the Pooh* was made in Acton, and that Billy Smart's circus originated in Greenford.

It was in Ealing that Pete Townshend of The Who decided smashing his guitar on stage would add to his art, and where the members of what would become The Rolling Stones met.

The borough was a favourite hideaway for the royal mistresses of Edward III, George IV and Queen Victoria's father, the Duke of Kent, and it is where bricks to rebuild Buckingham Palace were quarried.

Charlie Chaplin went to school in Hanwell, and the first man to carry an umbrella in London is buried there. Charles Blondin, who became world famous for his daring tightrope walks high above Niagara Falls, retired to the borough.

The sixties singer Dusty Springfield, the prima ballerina Margot Fonteyn, and Charles Richards, author of the Billy Bunter books, all spent their childhoods in Ealing, and the man who invented Daylight Saving Time lived in Acton.

Lady Byron – wife of the poet – and the novelist Henry Fielding owned the same house on the eastern side of Ealing Common, and Spencer Perceval, the only British prime minister to be assassinated, lived on the western side, where a church was erected in his memory.

All in all, Ealing is a good deal more interesting than its cosy suburban image suggests.

Acton Water

Acton Water was famed for its medicinal properties. In the eighteenth century, the discovery of mineral-bearing springs at Old Oak Common led to the development of a spa, and London's gentry came to Acton Wells House to take the waters. By 1746, Acton Water was also being sold in large quantities in London.

The waters were said to have similar properties to those at Cheltenham, previously considered the best in the country. But Acton, being far closer to the capital, was much easier for Londoners to get to, and became hugely popular. Taking the waters here became part of the summer social season. Public breakfasts and assemblies were held at newly established Assembly Rooms in May and June, and a racecourse was established. Summer lodgings were found at the hamlets of Friars Place and East Acton, to the south of the wells.

However, the spa fell out of fashion and, in 1790, the well house was demolished. Wells House Road, W3, is built on the site.

Wells House Road is built on the site of Acton's eighteenth-century spa.

The proliferation of laundries such as the Thistle Laundry earned Acton the nickname Soapsuds Island.

In Victorian times, Acton's waters made it popular with laundries. With new, cheap housing springing up, many women, whose hand laundries were squeezed out of rapidly gentrifying Notting Hill, moved here. By the 1860s the town housed 170 laundries and became known as 'Soapsuds Island' and the 'Washtub of London'. By the 1930s this and other industry made Acton the greatest industrial area south of Coventry.

Aerodrome

Where the Hanger Hill Garden Estate and the Royale Leisure Park are now was home to Acton Aerodrome in the early decades of the last century.

In 1909, Harold Piffard rented a field between North Ealing Station and Masons Green Lane and built an aircraft which he only managed to fly at a height of 1 to 2 feet and for just 100 yards. The following year the Alliance Aeroplane Company took over, building hundreds of planes over the next decade. During the First World War they made military planes for the de Havilland and Handley-Page aircraft companies.

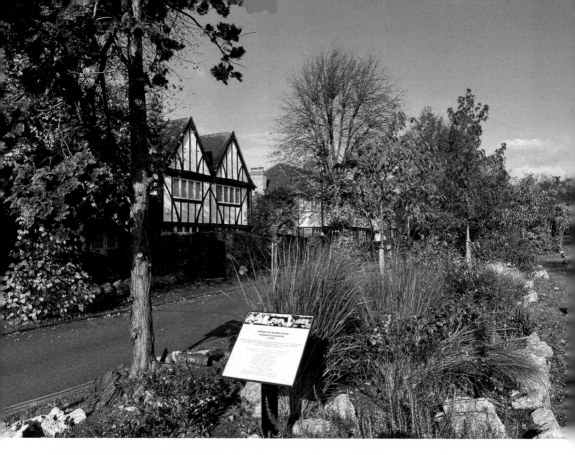

Above and left: Hangar Hill Garden Estate now covers Acton Aerodrome, where Alliance-built bi-planes were constructed.

ALLIANCE TYPE P1.

Extremely simple in details. Robust construction. Fuel cost 3¼d. per mile. Speed variation 30 to 77 M.P.H. range with pilot and two passengers, or 300 lbs. of mails, 300 miles. Dual control can be fitted if required.

The Owner-Driver's Machine.

ALLIANCE TYPE P4.

This machine has been specially designed for passenger-carrying over medium distances.

With four passengers and a pilot in a comfortable saloon, it has a range of 800 miles at a fuel cost of 4¼d. per mile.

It has a top speed of 107 M.P.H. and a landing speed of 40 M.P.H., which, combined with a wide tracked oleo undercarriage, renders it capable of being landed almost anywhere. The wings fold for storage purposes, bringing the span down to 15 ft.

For terms and particulars of this and other types, and appointments for demonstrations, apply to :—

The ALLIANCE AEROPLANE Co., Ltd.

Registered Offices :
45 EAST CASTLE STREET, LONDON, W.

Works:
CAMBRIDGE ROAD, HAMMERSMITH.

Works & Aerodrome:
NOEL ROAD, ACTON.

Alliance also built its own Seabird long-distance aeroplane, one of which won the 1919 Acton to Madrid air race. Sadly, later that year another Seabird crashed in Surbiton, killing the crew. They were on the opening stage of a race to Australia, in the hope of winning the £10,000 prize money. Alliance closed down the following year.

The mock-Tudor Hanger Hill Garden Estate was built on the southern half of the airfield in the 1920s.

Aeronaut

The Aeronaut, in Acton High Street, is dedicated to local aeronaut and daredevil George Lee Temple, the first Englishman to fly a plane upside down. George, nicknamed the Boy Airman because of his youthful appearance, was born in 1892 and lived at 9 Cumberland Park, W3. He attracted huge crowds to air displays, where

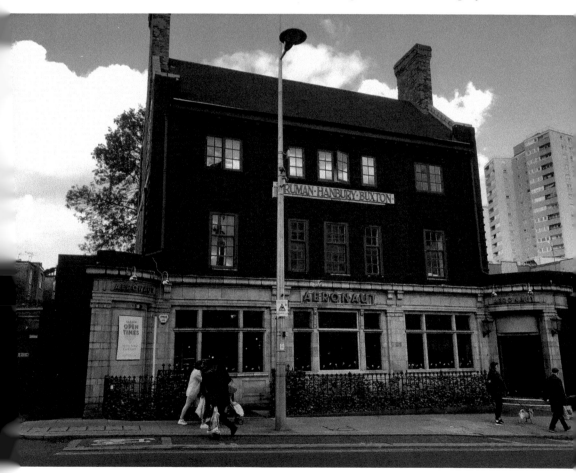

The Aeronaut is named after Acton flying ace George Lee Temple.

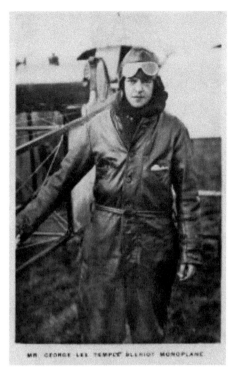
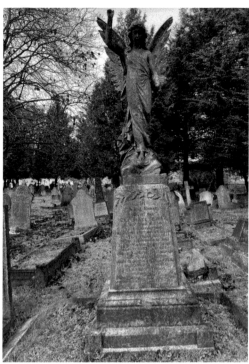

Above left and above right: George Lee Temple, and his grave in Acton Cemetery.

he performed stunts including dive-bombing straight down towards the ground and only pulling out a few feet from disaster.

He died during an exhibition flight at Hendon aerodrome in 1914 when a gust of wind flipped his plane over, causing him to crash and break his neck. George was buried at Acton Cemetery on Park Royal Road, where a large memorial was erected.

Art College

Among the students to find fame after attending Ealing Art College in the early 1960s are Freddie Mercury of Queen, Pete Townshend of The Who, and Ronnie Wood of The Faces and The Rolling Stones.

When Pete Townsend (see separate entry) enrolled in 1961 to study graphic design and conceptual art, he was already playing with Roger Daltry and John Entwistle in The Detours. By 1964 the group, renamed The Who, were opening for The Rolling Stones and The Kinks, and Pete found the double life he was leading – college by day, gigging by night – exhausting.

When he told the head of the graphic design department he was earning £30 a week – more than his tutor was making – he was advised to give up the course and concentrate on music. Which he did.

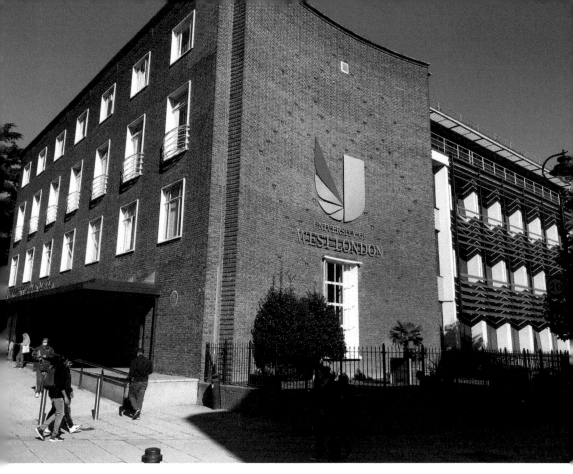

Ealing Art College, now the Ealing campus of the University of West London.

Ronnie Wood enrolled at the college in 1963 but also dropped out, to concentrate on his band, The Birds, which was signed by Decca but failed to make it big.

In his autobiography, *Ronnie*, he recalls going to see Eric Clapton performing with The Yardbirds, and being smitten by Eric's then girlfriend, Krissy Findlay, a model. Soon afterwards, he says: 'I got a flat with a few friends on Edgehill Road in Ealing near where Krissy was still living with her parents.'

When her parents left the town, Krissy stayed on in the family flat and Ronnie moved in with her. The couple married in 1971, but divorced in 1978. She died in 2005, at the age of fifty-seven, of a Valium overdose.

Ronnie's art is now as highly regarded as his music: his paintings are exhibited in top galleries around the world, and sell for five-figure sums.

Freddie Mercury, then known by his birth name of Fred Bulsara, was obsessed with Jimi Hendrix while a student at Ealing, and his work there was often inspired by Jimi's image and lyrics. Freddie, who attended from 1966 to 1969, was determined to make it as a musician, and used the £5 per session he earned as a nude model, posing at evening art classes at the college, to fund the many gigs he attended at Richmond's Crawdaddy Club.

The college, in St Mary's Road, W5, is now the Ealing campus of the University of West London.

Barnes Pikle

This alley running alongside the Filmworks development, linking Ealing Broadway and Mattock Lane, W5, once formed the western boundary of a small field, or 'pikle' owned by a Mr Barnes.

Bart, Lionel

The composer best known for *Oliver!*, the musical inspired by Charles Dickens's *Oliver Twist*, had an extraordinarily successful career during the 1960s, in which he composed pop hits including 'Living Doll' for Cliff Richard, 'Rock with the Cavemen', and 'Little White Bull' for Tommy Steele, and the theme song for the 1963 James Bond film *From Russia with Love*.

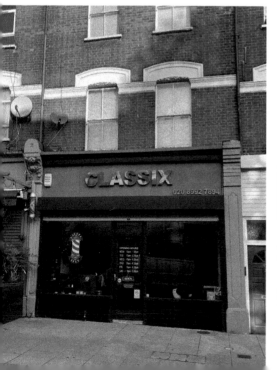

Above: Lionel Bart. (Allan Warren under Creative Commons)

Left: Classix barbers, Churchfield Road, which Lionel Bart often visited.

Oliver! won Lionel a Tony award for best original score, and the 1968 film version gained six Oscars. Andrew Lloyd Webber called him 'the father of the modern British musical'.

However, a series of flops led to bankruptcy, depression and alcoholism. With his years of fame and success behind him he moved to a flat at 33/35a Churchfield Road, Acton, W3, where he lived until his death in 1999. A previous tenant had been the singer Leo Sayer, who moved there after splitting from his wife.

Lionel Bart is still fondly remembered in the street, including by Tony Antoniou, who runs Classix barbers across the way at No. 44. Tony told *ActonW3* that Lionel Bart came in twice a week for coffee, a chat and a scalp massage, and often escaped to Classix when things got a bit much for him.

Once, when Bart was hosting a party, his flat became so packed that he came across to the barbers with Barbara Windsor, and sat reminiscing with her in a back room.

Blondin, Charles

The man internationally famous for his sixteen increasingly daring tightrope walks high above Niagara Falls spent his retirement in Ealing.

Charles Blondin, born Jean François Gravelet in 1824 in Calais, first made the crossing, on a rope suspended 1,100 feet above the falls, at the age of thirty-five. With each further crossing he came up with a new, more theatrical and increasingly

Charles Blondin, who crossed Niagara Falls on a tightrope.

dangerous gimmick. He crossed blindfolded; pushing a wheelbarrow; in a sack; on stilts; carrying his manager on his back; sitting down midway to cook an omelette; and balanced on a chair, with just one of its legs on the rope.

From 1886 until his death in 1897 he lived at Blondin House, which stood in Northfield Avenue across from Julien Road. The house was demolished in the 1930s, but Blondin Avenue, Niagara Avenue and Blondin Park are reminders of his connection with the area. Blondin is buried in Kensal Green Cemetery.

Borough of Ealing

In 1965, when Middlesex County Council was replaced by the Greater London Council, the towns of Southall, Acton and Ealing were amalgamated to become the London Borough of Ealing. Hanwell, Greenford, Perivale and West Twyford had joined with Ealing in 1926, Northolt in 1928.

Brentham Garden Suburb

Brentham's 680 Arts and Crafts houses and flats, arranged in small groups on tree-lined streets, were a pioneering development in the Garden City movement, a reaction to the overcrowding and squalor of many working-class areas in Edwardian London and other industrial cities.

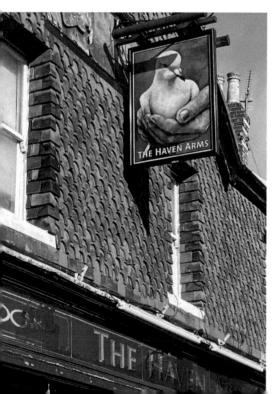

The Haven Arms, where the decision to build Brentham Garden Suburb was made.

Houses on Brentham Garden Suburb, a pioneering development of the Garden City movement.

Brentham Garden Suburb, in Pitshanger, W5, was the first development founded on co-partnership principles, under which tenants were shareholders in the society that developed the estate, and all housing was held in common. The idea was that the absence of private ownership would reinforce each tenant's personal interest in the prosperity of the development as a whole, and each shared in any profits.

The idea to build Brentham came from six Ealing followers of the movement who met at the Haven Arms in Haven Lane with Henry Vivian (1868–1930), a carpenter, trade unionist and Liberal MP. They formed a group called Ealing Tenants, and first built nine houses in Woodfield Road in 1901.

Encouraged by the success of this development, they bought a much larger parcel of land and, over the next five years, built Winscome Crescent, Ludlow Road, Neville Road, Ruskin Gardens, and parts of Brentham Way and Meadvale Road.

In 1911 a social hub, the Brentham Club and Institute, was added and in 1916 St Barnabas Church. From the 1930s the co-operative ethos lost favour, and houses were sold to private purchasers, but the estate is still a close-knit, supportive and friendly community.

Byron, Lady

Anne Isabella Noel Byron, wife of the poet, established an industrial school for boys in Ealing and lived in Fordhook House, which stood on the north-eastern border of Ealing Common.

As a strictly religious woman with strong morals, she was an unlikely partner for the agnostic and amoral poet, but believed it was her duty to reform him. However, she quickly realised she could not influence his behaviour, and left him shortly after the birth of their daughter, Ada.

Lady Bryon was terrified Ada could inherit her father's romantic excesses and mental instability, and believed an education in logic and mathematics might counter it. As Ada Lovelace she became a pioneer of computer science, famous for her work on Charles Babbage's Analytical Engine, the forerunner of modern computers.

Lady Byron lived at Fordhook House from 1822 to 1840. Ada was married at the house, which was demolished prior to redevelopment in 1910. The new Ada Lovelace Church of England High School in Park View Road, W5, is named in her honour.

In 1834 Lady Byron established the Co-operative School, training boys in practical skills including carpentry, gardening, cobbling and tailoring. The school closed in 1859 and a plaque stands at the site, the Ealing campus of the University of West London in St Mary's Road, W5.

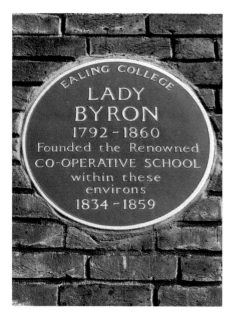 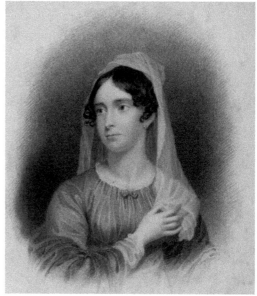

Above left: The plaque on the University of West London, St Mary's Road, where Lady Byron established a school.

Above right: Lady Byron lived with her daughter, Ada Lovelace, in Fordhook House, Ealing Common.

C

Chaplin, Charlie

As a seven-year-old, Charlie Chaplin became a pupil at a school for destitute children in Hanwell. His parents, Charles and Hannah, both music hall performers, had separated two years before, with Charlie and his older half-brother, Sydney, staying with Hannah.

She struggled as a single mother, and the family was forced to enter Lambeth Union Workhouse in June 1896, where they were separated. Charlie, who first appeared on stage at the age of five, and Sydney were transferred after three weeks to the Central London District School, known as the Cuckoo Schools, in Hanwell. There were over a thousand children at the school, equalling Hanwell's then small general population. It covered 112 acres and ran a farm.

The school, which closed in 1945, was off Westcott Crescent. The main building has survived in what is now Cuckoo Park, and houses Hanwell Community Centre.

In his book *Autobiography*, Chaplin recalls a brutal regime, involving harsh corporal punishment with cane and birch during which boys often passed out.

The former Cuckoo Schools, now Hanwell Community Centre. (Juan Gutierrez under Creative Commons)

Charlie Chaplin attended Cuckoo Schools in Hanwell.

After two months Hannah could not bear being parted from her boys, left the workhouse and came to collect them. Charlie and Sydney were delighted to be reunited with their mother, who spent the day playing with them in Kennington Park and took them to a coffee shop. But Hannah still had no way of supporting her family and, that evening, she returned the boys to the authorities. Charlie remained at the school until January 1898.

At the age of eleven, he was reunited with his mother along with Sydney but, shortly afterwards, Hannah was admitted to an asylum, and they went to live with their father, who was still a performer. Charlie went back on the boards, and in 1906 got his first big break as a music hall clown with Fred Karno's Mumming Birds Company. He toured America with Karno and, in 1913, caught the eye of film producer Mack Sennett, who hired him.

The tramp character Chaplin developed made him internationally famous, and the highest paid actor in Hollywood, but he never forgot the school, on one occasion organising coaches to take all the pupils to see one of his films.

Christ the Saviour

This landmark George Gilbert Scott church, which stands on Ealing Broadway beside the Dickens Yard development, only exists thanks to the generosity of two women parishioners.

The first, Miss Rosa Lewis, commissioned Gilbert Scott to create this 1852 Gothic Revival church to honour her father, William Thomas 'Gentleman' Lewis, one of the most distinguished comic actors of his day, who had died in 1811.

The sumptuous decoration of Christ the Saviour, Ealing Broadway, was paid for by parishioner Isabella Trumper.

Miss Lewis, who lived at Castle Hill House and died in 1862, personally funded the whole project, commissioning the hugely fashionable Gilbert Scott to design an imposing church with soaring spire, lofty nave and impressive vaulted roof.

The extensive internal decoration is thanks to a second parishioner, Isabella Trumper, who paid for G. F. Bodley to design the delicate and intricate pattern painted on the roof, the organ case with its Gothic cresting and angels in relief, and impressive pulpit.

The church was actually founded as Christ Church, but in 1951 it joined with St Saviours, a church in The Grove which had been destroyed by an incendiary bomb in 1940.

Cinemas

From 2008 until 2022 Ealing was without a cinema, a bitter disappointment given the suburb is the home of Ealing Studios, one of the most distinguished British movie houses.

That was rectified when the facade of the otherwise demolished Empire cinema in Ealing Broadway reopened as part of the Filmworks development of flats and shops. The Empire opened as the Ealing Forum Theatre in 1934, featuring Gracie Fields in *Love, Life and Laughter*, which was made in Ealing.

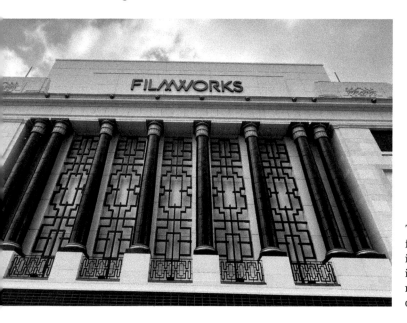

The façade of the former Empire cinema in Ealing Broadway is preserved in the new Filmworks development.

It underwent many changes in name and ownership before closing in September 2008. For fourteen years its facade, with its eight striking black columns, survived, shored up on an otherwise empty site.

Ealing's most architecturally distinguished cinema, the Spanish-style former Coronet in Northfield Avenue, survives as the Ealing Christian Centre. It opened in 1932 with a remarkable interior modelled on a Spanish courtyard beneath a tented roof, created by draping richly embroidered fabric from a central point in the ceiling that then flowed out to the walls, which were decorated with Moorish turrets, arches and backlit villa facades. Elaborate lanterns emitted a warm amber glow.

The cinema closed in 1985, the last feature – ironically – being *The Terminator*, featuring Arnold Schwarzenegger. Its Grade II* listing saved it from demolition to make way for a supermarket, and it survived as the Top Hat nightclub until 1994.

In 2000 the Cinema Theatre Association organised the first film show for fifteen years when it screened the classic Ealing comedy film *The Lavender Hill Mob* featuring Alec Guinness.

Crouch, Peter

The former Tottenham Hotspur and England player, now a TV presenter, has never forgotten his Ealing roots. In his *That Peter Crouch Podcast* he regularly refers to his days at North Ealing Primary School and Drayton Manor High School, and his family's favourite restaurant, the Samrat in Pitshanger Lane.

Peter, who attended the school from 1988 to 1992, told *MyLondon* that his days at North Ealing Primary were among the happiest in his life. He said:

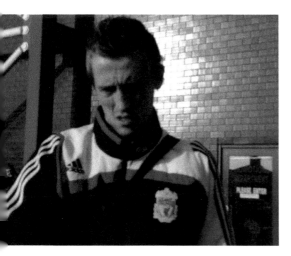

Above: Ealing boy Peter Crouch, former England footballer. (etyek under Creative Commons)

Right: The Samrat in Pitshanger Lane, Peter Crouch's favourite restaurant.

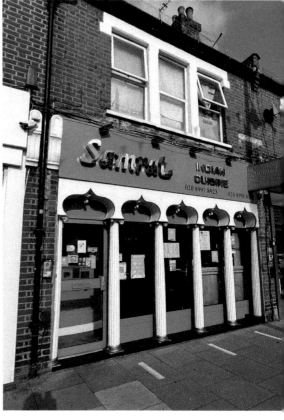

I had some great mates, and my six best mates from school, I still speak to them every week on the phone. We used to play as much football as we could. We would get into school early, at 8 a.m., play football before school, then in the break, then at lunchtime, and then after school in the park.

At the school's summer fetes he ran a penalty shoot-out stall, challenging members of the public to get the ball past the boy who would go on to score 22 goals in his 42 England appearances.

When Crouch went to Kensington Palace to interview Prince William for his podcast, the prince surprised him with a take-away delivery from the Samrat.

Coaching Inns

A major east–west route has run through Ealing, following today's Uxbridge Road, since the Middle Ages. In the coaching age, from the seventeenth to the nineteenth centuries, this was a busy route for stage and mail coaches running from central London to Oxford, Bristol and many other points west.

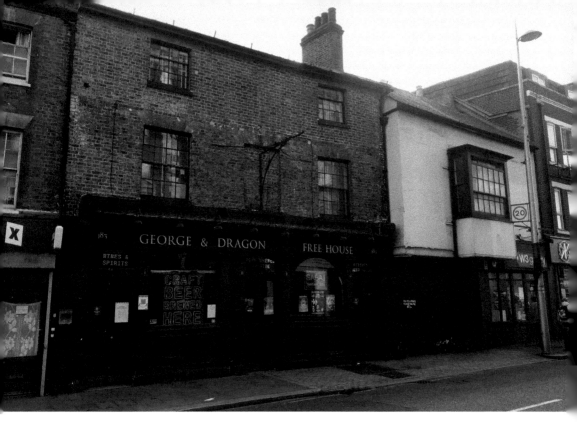

The George and Dragon in Acton High Street, one of Ealing's surviving coaching inns.

Regular staging posts were needed where horses and passengers could be refreshed, and there are still inns on many of those sites today. Among them are The Six Bells and George and Dragon in Acton High Street. The owners of the latter also ran their own coach, the *Acton Machine*, to Oxford Street each Saturday.

The Bell, in The Mall, W5, was a quaint cottage-style pub in the 1750s, very different to the Lodge Tavern which was established on the site following an office redevelopment in the 1960s. In the early nineteenth century it was a stop for the Royal Mail coach, which ran twice daily to Worcester, and for coaches headed to Oxford and Cheltenham.

In Hanwell, W7, The Viaduct, then the Coach and Horses, offered a handy stopping point where horses could be refreshed with water from the River Brent, which runs beside the inn. The Coach and Horses also offered overnight shelter for passengers wary of crossing the heath to the west, where highwaymen lurked after dark.

There was also a north–south coaching route from Perivale to Brentford – in part following the line of today's South Ealing Road. Inns on this route include the New Inn, Castle Inn, and Red Lion, all on St Mary's Road, W5, and the Rose and Crown in Church Place.

The New Inn, which dates from the seventeenth century, was a busy coaching stage-post in the early 1800s. The owners, the Ives family, also ran a coach to central London several times a day.

D

Delius, Frederick

A decade before he achieved fame as a composer, Frederick Delius came to Hanwell to stay with a young poet with whom he hoped to collaborate on an opera inspired by the story of Endymion, the beautiful youth who, in Greek myth, spent much of his life in perpetual sleep.

Delius was thirty when, in February 1892, he stayed with the twenty-six-year-old Richard Le Galliene and his wife Mildred at Meadowsweet, 3 Cambridge Gardens, now 33 Church Road, Hanwell, W7.

Shortly after the visit, in February, Richard wrote of Delius: 'He is sure to do something. I never saw a man with such an irresistible will, and as it is directed with intelligence, he is sure to come to the front. Certainly he deserves to. We have sketched out the plot of a little opera together on the story of Endymion.'

Frederick Delius worked on an early opera in Hanwell. (Bergen Public Library under Creative Commons)

Among Delius's best-known works are *A Mass of Life* and *A Village Romeo and Juliet*, in particular the orchestral interlude in that work called 'Walk to the Paradise Garden'.

In fact, the collaboration with Le Galliene came to nothing but, during his week-long visit, Delius was introduced to several literary figures who would inspire some of his greatest compositions. Richard was a member of the Rhymers' Club, along with W. B. Yeats, Max Beerbohm, Oscar Wilde, Paul Verlaine and Edmund Gosse.

Jane Armour-Chélu writes in the *Delius Society Journal* that: 'The Le Galliennes attended the first night of *Lady Windermere's Fan* at the St James Theatre, in company with Delius. In his autobiography, Le Gallienne recalled his conversation with Oscar Wilde, who came over to greet them in the foyer after the performance.'

Department Stores

Department stores were once a feature of Ealing, with two imposing buildings facing each other across Ealing Broadway's junction with the High Street and Springbridge Road.

On the corner of Broadway and Springbridge stood the grand domed building originally occupied by the family drapers Eldred Sayers, taken over by Bentalls in 1950. When the Ealing Broadway Centre was opened to the south-east of the junction in 1985, Bentalls moved into the centre and the original store was demolished, to be replaced the next year by the unsuccessful Waterglade Centre, later remodelled as Arcadia and housing T. K. Maxx and Morrisons. Primark took over Bentalls' Ealing Broadway Centre site in 2008.

Across from the original Bentalls stood the distinctive modernist John Sanders store. It is now Marks and Spencer.

The original John Sanders developed piece by piece on Ealing Broadway in the 1880s. Sanders – born in Devon in 1842 and later apprenticed to a milliner in St Leonards, East Sussex – identified Ealing as a good business proposition with the coming of the Great Western Railway. He opened a small drapery store here, and gradually bought up adjacent shops, adding departments specialising in hosiery, millinery, furnishings and funeral services. By 1890, Sanders had created a department store.

In 1925, at the age of eighty-three, he sold out to the three Rowse brothers, who already had a department store in West Ealing. They amalgamated the individual units in 1932, but in 1944 enemy bombing destroyed the store. It wasn't until 1965 that an elegant new building rose from the ashes. So impressive was it that, when Ealing council decided to create a shopping centre in the town, they built it behind John Sanders, which was expanded to link with it. In 1990, the Rowse brothers sold out to Marks and Spencer.

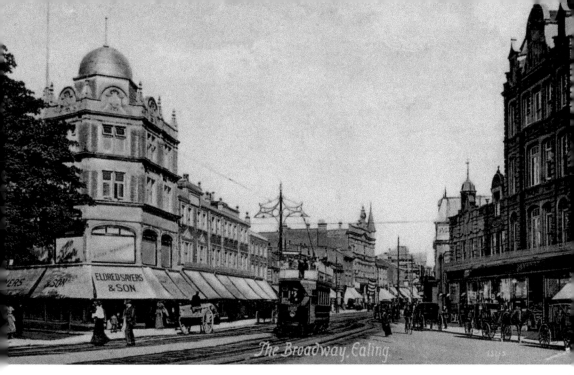

Above: Ealing Broadway department stores Sayers and John Sanders.

Below: The Arcadia centre replaced Bentalls, which had replaced Sayers.

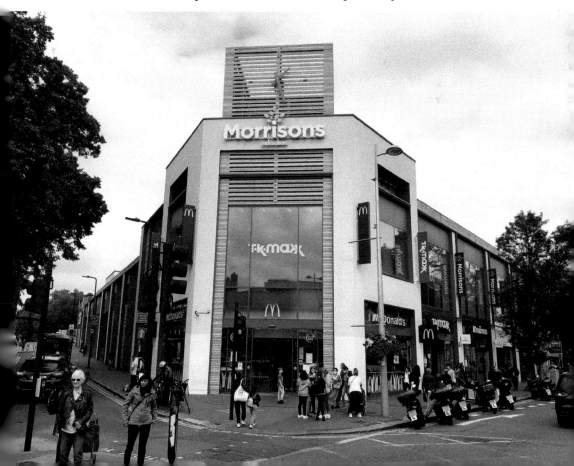

Dodd, Dr William

William Dodd, the last man to be executed for forgery, lived in a substantial house on the corner of the South Ealing Road and Pope's Lane, W5, where he ran a school, from 1769.

Dodd (1729–77) was an Anglican clergyman whose lifestyle was unusual for a man of the cloth. He was extravagant, an obsessive gambler, and an incurable romantic who married Mary Perkins, the daughter of a domestic servant.

Despite achieving – and losing – the elevated position of chaplain to George III, and winning £1,000 in a lottery (£250,000 today) he became mired in debt and resorted to forgery in an attempt to obtain a loan of £1 million (in today's money), but was exposed and condemned to death.

The essayist Samuel Johnson headed a campaign for a pardon, but Dodd was publicly hanged at Tyburn in June 1777.

Dye Factory

At the age of eighteen, William Henry Perkin was a student at the Royal College of Chemistry (now part of Imperial College London) and was attempting to synthesise quinine for the treatment of malaria.

He failed in that enterprise but, while conducting his experiments in 1856 he discovered, by accident, that an organic compound called aniline could be transformed into a substance with an intense purple colour.

His invention would revolutionise the world of fashion, ushering in an age where many vivid colours could be created and used to bring a new kaleidoscope to clothing. And, because he had the foresight to patent his discovery, it made him his fortune, and earned him a knighthood.

To exploit the discovery he established a dye factory beside the Grand Union Canal at Oldfield Lane North in Greenford. It was the first such factory in the world, and pioneered the creation of synthetic dyes. He gained royal approval when Queen Victoria wore a mauve gown at the Royal Exhibition in 1862.

Sir William went on to create a synthetic brilliant red, a violet and a green. It was said that the colour of the canal changed depending on what colour Perkins was developing.

E

Ealing Club

The Rolling Stones formed after the members met at the Ealing Club, a pioneering early sixties venue in a cellar beneath a cafe opposite Ealing Broadway station. Stars who either played or attended gigs here in their formative years include Cream, The Who, Manfred Mann, The Yardbirds, John Mayall, Fleetwood Mac and David Bowie. The Stones played here twenty-two times.

At this tiny cellar bar at 42a The Broadway, a new sound – British rhythm and blues – was created, making it as important in music history as Liverpool's Cavern. It featured a combination of electric guitars and pounding drums, and was heavily influenced by Black American blues. It inspired a generation of bands including The Beatles.

The club, founded by musicians Alexis Korner and Cyril Davies, opened on 17 March 1962. In his autobiography, *Life*, Keith Richards wrote: 'Without them there might have been nothing.'

There might have been no Rolling Stones, either. It was here that, on 24 March 1962, Brian Jones met Charlie Watts. A couple of weeks later, on 7 April, Alexis Korner introduced Mick Jagger and Keith Richards to Brian. The classic line-up of the Stones

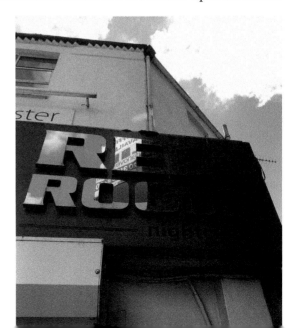

The Ealing Club, now the Red Room.

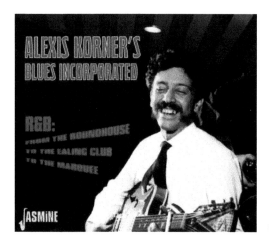

Left: Alexis Korner recorded pioneering British rhythm and blues at the Ealing Club.

Below: The members of The Rolling Stones met at the Ealing Club.

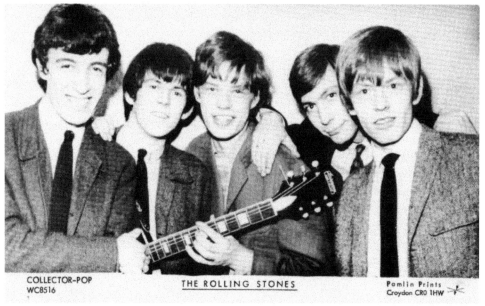

first performed here on 13 January 1963, with Charlie becoming their permanent drummer at an Ealing gig on 2 February. History was made.

The club, which has since been a casino and a disco, is now The Red Room, a nightclub where live music is once again performed.

Ealing Studios

Ealing has played a substantial role in film history. Ealing Studios on Ealing Green produced the highly popular and influential Ealing comedies in the 1940s and 1950s, and is still very active.

Ealing Studios, where world-famous Ealing comedies were filmed.

However, the link with film goes back to 1902, when Will Baker bought the white house headquarters that still stands, and went on to produce the first really important British film, an adaptation of Shakespeare and Fletcher's *Henry VIII*, in 1910.

Since then, filming has never stopped, making this the oldest continuously working studio in the world.

The golden age of Ealing film-making began in 1938 when Michael Balcon took over the studios. For the next three decades, Balcon oversaw the creation of classic films – especially comedies – culminating in masterpieces such as *Kind Hearts and Coronets*, *Passport to Pimlico*, *The Lavender Hill Mob*, *Whisky Galore!*, *The Ladykillers* and *The Man in the White Suit*. Ealing comedies often shared the common theme of the little man triumphing over bureaucracy and large corporations: films which were quintessentially English in their ethos and values.

The BBC took over the studios in 1955 and many TV shows were filmed here and on location around Ealing, including *Porridge*, *Monty Python* and *Dr Who*. A consortium of independent film-makers has run the studios since 2000, and many TV shows and movies are still made here.

Ellis, Sir William

In the nineteenth century, attitudes to mental illness differed starkly to those of today. Inmates at what were called asylums were treated as objects of ridicule and sources of amusement for visiting gawpers.

That changed in 1831, when Dr Ellis became superintendent of the first purpose-built asylum in England. Sir William pioneered an enlightened approach in which inmates were treated with humanity, and engaged in occupational therapy.

St Bernard's Hospital, the first humanely administered institution for the mentally ill. (P. G. Champion under Creative Commons)

The Middlesex County Asylum, later known as St Bernard's Hospital, is alongside Ealing Hospital, on the Uxbridge Road in Southall. This was the first of what were known as pauper lunatic asylums built in England following the Madhouse Act of 1828. Within four years, the three-storey, yellow-brick building, built to a striking octagonal design, held 1,302 patients looked after by ninety staff. By 1888 there were 1,891 patients, in what had become the largest asylum in Europe.

Together with his wife, who was matron, Ellis ensured the hospital became a model for enlightened psychiatric care. Patients were encouraged to use the trades and skills which had occupied them in the outside world. The 74-acre grounds were farmed by inmates, thanks to which, along with a laundry, bakery, brewery and gasworks, the hospital was largely self-sufficient.

A dock was built on the Grand Union Canal behind the hospital, where coal was delivered and produce taken away for sale.

Dr Ellis left in 1838, but Dr John Conolly added further reforms, abolishing the use of mechanical restraints for violent or non-cooperative patients in favour of padded cells, solitary confinement and sedatives.

In 1979, Ealing Hospital was built on part of the land, and another section was later sold for housing. St Bernard's is now part of the West London Mental Health (NHS) Trust and continues to provide forensic and acute mental health treatment for 376 patients.

Evacuees

No fewer than 100,000 Second World War child evacuees passed through Ealing Broadway station in the first four days of September 1939 as they transferred from tube trains onto GWR overground services for their journey to safer homes to the west of the capital.

F

Fair

A raucous three-day midsummer fair was held on Ealing Green from the eighteenth century, attended by traveller families, as well as locals and visitors from across London. It featured grinning contests in which the biggest smile could win a leg of mutton; tea-drinking competitions in which old ladies tried to win a pound of tea; and races to catch – and win – a pig. There were acrobats, performing poodles and freak shows.

However, as Ealing was transformed from a rural backwater to a modern suburb in the 1860s and 1870s, opposition grew among newcomers and the authorities to the smell and noise, and to an event that was said to encourage lawlessness, drunkenness and debauchery.

Raucous, three-day midsummer fairs were held on Ealing Green.

Ealing Council lobbied the Home Secretary to invoke the 1871 Fairs Act and declare the event illegal, which he did in 1880. Yet, not everyone got the memo and, that Midsummer's Eve, the caravans and stalls arrived on Ealing Green as usual.

Inspector Wills of Ealing's police force called in reinforcements, and officers barricaded the Green and turned caravans around. A crowd grew of people who had come to enjoy the fair. Disappointed, they went to drown their sorrows at the Red Lion and other pubs.

By closing time, they were drunk and angry, and a mass of protesters tried to occupy the green. The police drew batons and charged, driving them back. Stones were thrown and one man was arrested when a constable was struck and injured.

Ealing's fair was never held again.

Fielding, Henry

The author of *Tom Jones* bought Fordhook House on Ealing Common as a country retreat in 1752, possibly with the income from the novel. It stood where Fordhook Avenue is now, opposite Ealing Common Station.

Fielding spent considerable time at the two-storey, stuccoed, bay-fronted house over a number of years because, he said, the air in Ealing was the 'best in the kingdom'. In May 1754 he came here, in failing health, to get away 'from the smells and smoke of London'. However, on this occasion Ealing failed to work its magic. Fielding set off for Lisbon, suffering from dropsy (water retention), but died there that November.

Fordhook was later lived in by Lord Bryon's widow (see entry for Lady Byron) and was demolished in 1903 when the area was developed for housing.

Fonteyn, Margot

The legendary ballerina Margot Fonteyn (1919–91) spent six childhood years in Ealing. She was named Peggy Hookham when her parents moved from Reigate to Waldeck Road, W13. While living here Peggy went to her first ballet lessons, at a school close to Ealing Common run by Grace Bosustow. The school was accredited by the Association of Operatic Dancing, forerunner of the Royal Academy of Dancing, of which Margot would one day become president.

She received her first review, at the age of five, in the *Middlesex County Times*, for a charity performance in which, the paper reported, there 'was a remarkably fine solo dance by Peggy Hookham, which was vigorously encored'.

The family later moved to 3 Elm Grove Road, a house much closer to the dance school, but when she was eight her father's job took the family to China, where Peggy continued to study dance.

Right: Margot Fonteyn's former family home in Elm Grove Road.

Below: Margot Fonteyn and Rudolph Nureyev. (Mr Nostalgic under Creative Commons)

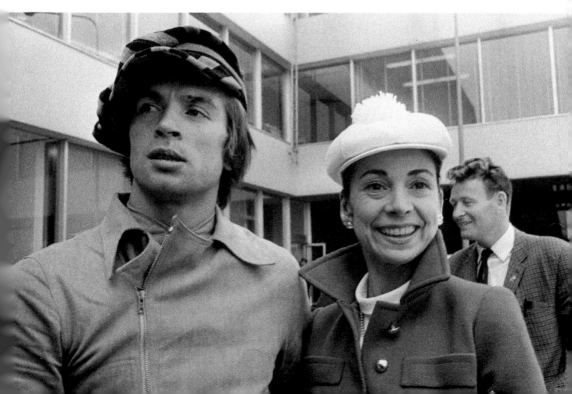

At the age of fourteen she was brought back to London, her mother more determined than Peggy that she should succeed as a ballerina, and joined the forerunner to the Sadler's Wells Ballet. She changed her name first to Margot Fontes, then Fonteyn, making her solo debut in 1935, becoming prima ballerina in 1939.

In 1961 she was expected to retire, but instead embarked on her most famous performances alongside Rudolph Nureyev, most notably in *Sleeping Beauty* and *Swan Lake*, at the Royal Ballet. They travelled the world together in a partnership that lasted until 1979.

Friars Place

This stately home, which stood where Friars Place Lane is in East Acton, was once lived in by Oliver Cromwell's son Richard. It became the site of a Walls sausage factory in 1919, then an ice cream plant in the 1950s.

Acton was garrisoned by Parliamentary troops during the Civil War, and Friars Place was the headquarters of the Earl of Essex, their commander. In November 1642 he led a victorious attack on Royalist forces from here, forcing them to abandon their march on London. This became known as the Battle of Turnham Green, but actually took place on Acton Green Common.

Walls, which called their factory The Friary, began making ice cream in the summer months when sales of sausages fell. It was from here that Walls' famous stop-me-and-buy-one tricycles fanned out.

By 1960, 20 million tons of ice cream was produced each year. In 2020 the site, which had closed in 1988, was developed for 1,000 homes.

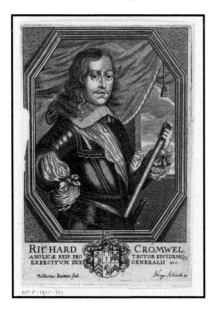

Richard Cromwell, son of Oliver, lived at Friars Place, Acton.

Ghosts

Ealing's most haunted building would appear to be St Dunstan's Church, Friars Place Lane, W3. Although the church dates only from the nineteenth century, it is close to the site of the fifteenth-century monastery of St Bartholomew, which stood at Friars Place.

The first to experience the ghosts was Revd Philip Boustead, curate at St Dunstan's in the 1930s, who spoke of seeing a procession of monks wearing gold and brown hooded habits.

In 1946, Revd Hugh Anton-Stephens, who had been vicar of St Dunstan's for two years, regularly saw up to a dozen monks in golden brown habits walk up the central aisle of the nave and into the chancel. They did so, he said, almost every evening.

He recounted other manifestations. Sometimes a ghostly monk in vestments would celebrate mass in the memorial chapel. Another, in violet robes, spoke to

Monks are said to haunt St Dunstan's Church, Friars Place Lane, Acton.

Anton-Stephens who, rather than finding such visitations disturbing, saw this as 'a ministering spirit, sent to inspire and instruct. I am indebted to him'. The ghost, he said, gave him advice about confirmation classes.

Later that year Kenneth Mason, a journalist, saw six monks process up the aisle, passing right through him. As they did so he heard a voice say: 'This is our past, this is our future', which he interpreted as referring to the former monastery. The monks continued to the altar, where they made the sign of the cross before vanishing through a wall.

In other accounts the monks first process up Friars Place Lane before entering the church. Such manifestations appear to follow a four-year cycle. Anton-Stephens, who died in 1962, insisted throughout his life that the figures he saw had objective reality.

Gilbert, Thomas

Thomas Gilbert, a Scottish Congregationalist clergyman, was granted St Mary's Church in St Mary's Road, W5, in Cromwell's time. When Charles II was restored to the throne, he was the first Puritan minister in the country to lose his parish. Gilbert, who said he wished to have it recorded on his gravestone that he was a 'proto-martyr to the cause of non-conformity', joined the Pilgrim Fathers in the United States.

It seems that many in his Ealing congregation shared his Puritan views. Baptisms during the period show traditional Anglo-Norman names such as William and Henry fell out of favour, while the more Biblical Gideon and Amos grew in popularity.

Thomas Gilbert, vicar of St Mary's, Ealing, in the seventeenth century, joined the Pilgrim Fathers in America.

However, not all approved of Gilbert's preaching. In 1655, an Ealing cheesemonger called Hugh Cotton was bound over to keep the peace after 'questioning and disturbing' the minister 'in the time of public and divine service' at the church in St Mary's Road.

Grace, W. G.

William Gilbert Grace (1848–1915) is perhaps the most famous English cricketer of all time, playing at the highest level of the game for a remarkable forty-four seasons, from 1865 to 1908. Grace captained England, Marylebone Cricket Club (the MCC), Gloucestershire and others.

Despite this, he was only ever officially an amateur, his profession being medicine, which he studied in tandem with his cricketing career.

In 1878, his final year at medical school, he lived at No. 1 Leamington Park Road, on the corner with Horn Lane, Acton, W3, while assigned to Westminster Hospital.

This was a hugely significant period for Grace. The previous autumn he nearly retired from cricket after almost losing the sight in his right eye in a shooting accident.

However, while living in Acton he gradually recovered and, during his time at Leamington Park Road, played in thirty-three matches, gradually regaining his confidence. With final exams looming, he did not play during the 1879 season until June, when he could afford to concentrate on sport.

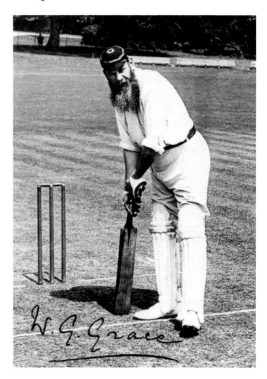

The famous cricketer William Gilbert Grace lived in Acton while studying medicine.

Great Ealing School

Ealing once boasted a school that rivalled Eton and Harrow in its nineteenth-century heyday, and which counted among its pupils William Makepeace Thackeray, author of *Vanity Fair*; Captain Frederick Marryat, author of *Mr Midshipman Easy* and *The Children of the New Forest*; John Henry Newman, who would become a cardinal in the Catholic Church, and who was canonised in 2019; and Sir W. S. Gilbert, who with Arthur Sullivan wrote a string of hugely successful light operas including *HMS Pinafore, The Pirates of Penzance* and *The Mikado*.

The school was founded in 1698 in Ealing rectory which, at the time, was a grand moated house with an extensive garden that stood beside St Mary's Church in St Mary's Road, W5. It had a swimming pool, cricket pitch, five tennis courts, and a row of five cottages converted into studies for the boys.

Among the teachers was the man who would go on to become the last king of France. Louis-Philippe taught mathematics and geography to support himself, while in exile, from 1800 to 1815.

In 1847 the rectory became infected with dry rot and the school moved across the road to a point opposite the current Ealing campus of the University of West London. Its reputation fell over the following fifty years until, in 1908, it closed. The houses of Cairn Avenue and Nicholas Gardens were built in its grounds.

In his book *The History of Henry Esmond*, Thackery has his hero spend his early years in 'a little cottage in the village of Ealing'.

Above left and above right: Pupils of Great Ealing School included Cardinal John Henry Newman, now a saint, and Sir W. S. Gilbert.

Gunnersbury House

The history of Gunnersbury House and its park stretches back to the eleventh century when it was reputedly owned by Gunylda, niece of King Canute. The estate has had several powerful and interesting owners since including, in the eighteenth century, Princess Amelia, daughter of George II.

However, perhaps the most intriguing former occupant is Alice Perrers (or Pierce) who worked her way up from being a maid to Edward III's wife Philippa to become the king's mistress, in 1366. Edward was bewitched by her, showered her with gifts and allowed her huge status and influence.

Kate McEwen, in *Ealing Walkabout*, writes:

> After the queen's death, Alice's power knew no bounds. She insisted on sitting in the public courts of justice wearing the late queen's jewels (which Edward had signed over to her) and so interfered in state affairs that Parliament, which had watched the king deteriorate from a staunch old war-horse to a drooling lap-dog, forced her to take an oath 'never to return to the king's presence'. Despite this, she seems to have been at his death-bed, and to have stolen the rings from his fingers.

Alice was banished by Richard II, who confiscated her estate which, thanks to the late king's generosity, stretched far beyond Gunnersbury to include most of the land between Ealing and Hammersmith.

In 1926, Gunnersbury was bought from later owners the Rothschild family (see separate entry), and is now administered by Ealing and Hounslow councils, whose borders it straddles, as a museum and park.

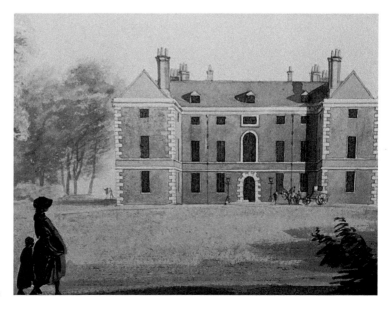

Gunnersbury House as it was in the eighteenth century.

Hanger Lane Gyratory

Once, Hanger Lane was a quiet route meandering through fields from Ealing to Alperton, and its junction with the stagecoach road to Oxford a simple crossroads.

Today, those roads are – respectively – the A406 North Circular, and Western Avenue, the A40, and they meet at the Hanger Lane Gyratory. Here, up to 10,000 vehicles an hour grind their way around an eight-lane-wide elongated roundabout. In 2007 it was voted Britain's scariest road junction in a survey conducted by the Highway Insurance Company.

While, since 1963, the A40 has run in an underpass beneath the gyratory, traffic wanting to switch between it and the North Circular, or the A4005 for Sudbury, which peels off from here, must still brave the traffic light-controlled junction.

The name Hanger is derived from the Old English word 'hangra', meaning a wooded slope, and the area to the south-west of the junction is known as Hanger Hill.

Hanger Lane Gyratory, Britain's scariest road.

A hamlet of that name once existed where Hanger Lane underground station now stands, encircled by the gyratory.

Hanway, Jonas

A man described on his memorial stone in Westminster Abbey as 'the friend and father of the poor' is buried at St Mary's Church, Hanwell.

Jonas Hanway (1712–86) was a merchant, traveller, campaigner and philanthropist. As a campaigner he fought for the rights of British seamen, founding the Marine Society in 1756, and against the exploitation of prostitutes and child chimney sweeps. As a philanthropist he was a key supporter of the Foundling Hospital, established in 1739 to shelter orphaned and abandoned children. He published seventy-four pamphlets expounding good causes, and books on his world travels.

He was also a pioneer, the first man in London to carry an umbrella. Women had used them since 1705, but when Hanway did so he attracted the ridicule of Hackney carriage drivers who jeered and jostled him.

He was also something of an eccentric, convinced that tea drinking was the scourge of the nation. He argued in *An Essay on Tea* that the drink was 'pernicious to health, obstructing industry and impoverishing the nation'. He claimed it caused ugliness and bad breath and was weakening the population. He believed the tea trade with

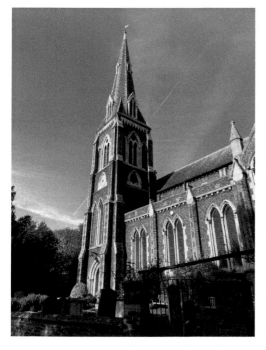
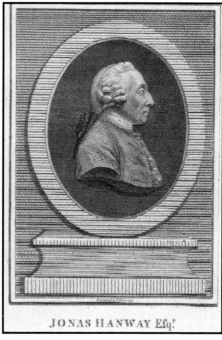

JONAS HANWAY Efq!

Above and above right: St Mary's Hanwell, where Jonas Hanway is buried.

China was syphoning money out of the country, reducing the nation's wealth and robbing it of funds that should be used on defence.

He came to be buried in Hanwell, despite living in Red Lion Square, central London, because of his friendship with the rector at St Mary's, Dr Samuel Glasse, who he visited frequently.

Haven Green

Haven Green was a rural retreat where partridge and hare were hunted before the Great Western Railway built Haven Green Station (now Ealing Broadway) in the 1830s as the first stop on the Paddington to Maidenhead line. The District Line opened its adjacent station in 1910, and the Central Line arrived in 1920. They have recently been joined by Crossrail, renamed the Elizabeth Line, the high-speed route running from Maidenhead and beneath the capital to Shenfield and Abbey Wood.

Haynes, Arthur

The comic actor Arthur Haynes lived in Gunnersbury Avenue, W5, where he died of a heart attack in 1966, at the age of fifty-two.

Haynes was one of the biggest TV comedy stars, appearing – often as his most popular comic character, a tramp – in fifteen series of ITV's *The Arthur Haynes Show* from 1956–66. Shortly before his death, Haynes seemed poised for Hollywood stardom. He had a cameo role as a London cabbie in *Strange Bedfellows* with Rock Hudson and Gina Lollobrigida in 1965, and Cary Grant was urging him to try for starring roles.

With a touch of comic irony, the plaque recording his residence at No. 74 Gunnersbury Avenue, where he lived from 1963, has been put up slightly askew.

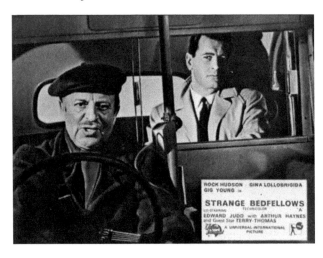

The comic actor Arthur Haynes, who lived in Gunnersbury Avenue, starred in *Strange Bedfellows* with Rock Hudson. (Universal International)

Hill, William Ebsworth

One of the most famous violin makers, William Ebsworth Hill (1817–1895), worked in Church Road Hanwell from 1890 and lived at Heath Lodge in Cherington Road, W7. He was the Hill family's fifth generation of violin makers and restorers, with a central London showroom in New Bond Street. The company had many distinguished customers including – it is thought – Pepys, in 1660. William's passion was the restoration of historic violins and he was the leading Stradivarius expert of his day.

Further generations of Hills ran the Hanwell workshop, before moving the business to Great Missenden, Buckinghamshire, in 1979, from where it still operates. The Hill Collection of antique musical instruments is in the Ashmolean Museum, Oxford.

Ho Chi Minh

The revolutionary and Vietnamese leader Ho Chi Minh worked in the kitchens at the Drayton Court Hotel in The Avenue, West Ealing, in 1914.

As a young man, Ho (1890–1969) travelled the world, working on ships and in hotels. He shovelled coal as a stoker on the ship that brought him to England, then worked for a short stint at the Drayton Court, where he lived in a small staff bedroom in the attic.

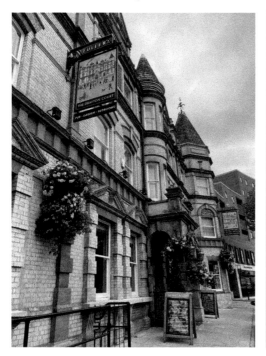 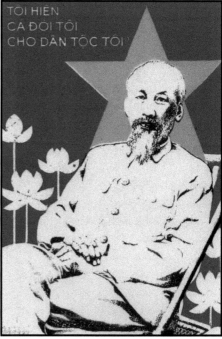

Above left and above right: The Vietnamese communist leader Ho Chi Minh worked in the kitchens at the Drayton Court Hotel.

The Marxist-Leninist led the Vietnamese independence movement from 1941, driving the French out in 1954, and was a key figure in the 1955–75 Vietnam War, in which North Vietnam triumphed, forcing out American forces, leading to the reunification of North and South Vietnam in 1976.

Huxley, Thomas Henry

The biologist, known as 'Darwin's Bulldog' for his championing of the theory of evolution, was born and educated in Ealing.

Thomas Henry Huxley (1825–95) was a pupil – and the son of a maths teacher – at Great Ealing School (see separate entry). However, the closure of the school when Thomas was ten plunged the family into poverty, and ended his schooling. Despite this setback, Huxley educated himself, becoming an eminent biologist and anthropologist.

In 1860, seven months after the publication of Charles Darwin's *On the Origin of Species*, he triumphed in a debate at the Oxford University with the Church of England bishop Samuel Wilberforce, who opposed Darwin's theories as being ungodly. Wilberforce, one of the greatest public speakers of his day, asked whether it was through his grandfather or grandmother that Huxley was descended from a monkey.

Thomas replied that while he would not be ashamed to be descended from a monkey, he would be ashamed to be connected with a man who used his great gifts to obscure the truth. The exchange marked a key point in the wider acceptance of Darwin's theories.

Huxley helped develop modern scientific education, and coined the term 'agnosticism', which has come to mean being unsure about the existence of God but to him meant to follow reason and not claim something was certain unless it could be proven objectively.

As an anthropologist, Huxley excelled as a comparative anatomist, working on the relationship between humans and apes, and demonstrating that birds evolved from small dinosaurs.

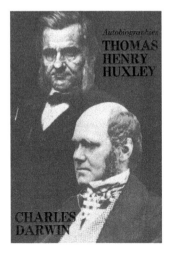

Thomas Henry Huxley was known as 'Darwin's Bulldog' because of his staunch support for the evolutionist's theories.

I

Industry

In the 1920s and 1930s Ealing became home to a slew of modern industries with a string of elegant, often art deco factories being built along the new arterial roads.

Western Avenue (A40) was lined with firms including Hoover, Guinness, and Aladdin light bulbs.

The 1933, Grade II* Hoover vacuum cleaner factory and head office became a Tesco in 1989, and Aladdin closed in the early 1980s and is now a branch of Dunelm. The Giles Gilbert Scott-designed Guinness brewery, which quenched the thirst of the southern half of the country from 1936, closed in 2005. Attempts to list the building failed and it was demolished.

At Bridge Park, Greenford, in 1921, J. Lyons and Co. created a sprawling factory covering 64 acres, in which a workforce of over 3,000 produced tea, coffee, cocoa, and chocolate, plus frozen foods and Ready Brek cereal. From 1958 it turned out millions of Lyons Maid cones and lollies.

The company was taken over by Allied Breweries in 1978 and many of the brands were sold off, leading to the closure of the site in 1998, and the development of the Lyon Way Industrial Estate.

The Hoover Building, now a Tesco. (Ewan Munroe under Creative Commons)

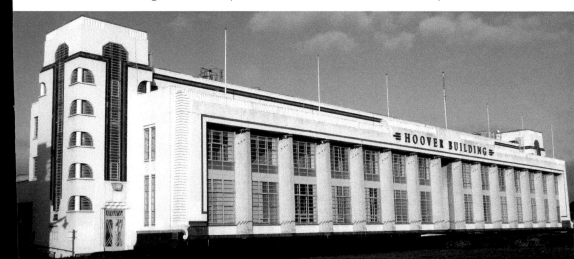

Jackass Common

Ealing Dean Common, which once ran along the south side of Mattock Lane, was known as Jackass Common due to its use for pony races on public holidays. The name was considered vulgar by the vicar of nearby St John's, and 20 acres became Ealing Dean Common Allotments (now Northfield Allotments) in 1832. Steeplechases continued on the rest of the land until it was built on in the 1870s.

The allotment area has been whittled down by 60 per cent over the intervening years. Originally it continued to the west of Northfield Avenue, but that section became Dean Gardens, a public park, and the Dean Court housing development.

James, Sid

The comic actor Sid James (1913–76) lived in Ealing for seven years at the height of his fame as a *Carry On* star. Sid, born in South Africa as Solomon Joel Cohen, lived at 35 Gunnersbury Avenue, a four-bedroom, bay-fronted detached house with a 100-foot garden, from 1956 to 1963.

Sid already had a strong professional connection with Ealing, through appearances in classic Ealing comedies such as *The Titfield Thunderbolt* and *The Lavender Hill Mob*, starring alongside Alec Guinness in a film ranked seventeenth in the best 100 British films by the British Film Institute.

James appeared in the groundbreaking radio sitcom *Hancock's Half Hour*, starring Tony Hancock, from 1954 to 1959, also transferring to the television version in 1956 for four years. However, he is best known today for the nineteen *Carry On* films he appeared in.

One, 1960's *Carry On Constable*, was filmed extensively in Ealing. Scenes were shot in The Avenue, featuring the parades of shops at the southern end, and the Drayton Court Hotel; St Mary's Road; the Royal Mail Sorting Office in Manor Road; and at Hanwell Library in Cherington Road, which morphed into a police station.

Sid was married three times, and moved to Ealing with his third wife, Valerie, who he married in 1952. The couple had two children, Steve and Sue. During this

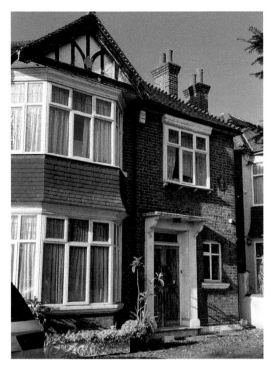 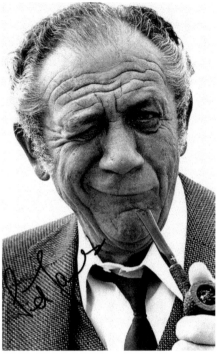

Above left and above right: The *Carry On* star Sid James lived at 35 Gunnersbury Avenue.

marriage, Sid conducted a well-publicised three-year affair with his *Carry On* co-star Barbara Windsor.

Asked about the nature of his appeal to audiences, Sid once said: 'I'm the eternal dirty old man. I'm a car salesman by nature, a jockey by profession, and as far as the birds go ... gor blimey!' He died on stage during a performance at the Sunderland Empire.

Jamiroquai

Jay Kay, founder of the band Jamiroquai, attended Twyford Church of England High School in Acton and lived on Grange Road, Ealing. Born in 1969 as Jason Luís Cheetham, Jay Kay was brought up by his mother, the cabaret singer Karen Kay, and did not meet his father, the Portuguese guitarist Luís Saraiva, until he was in his thirties.

Jay Kay had an itinerant childhood, mixing Manchester, Suffolk and Devon with Ealing, but played some of his early gigs while living here. In 2002 he returned to Ealing for a homecoming gig at Broadway Boulevard, screened by Channel 4, and said: 'Ealing is where I really got my musical shit together, from making demos in a squat to coming up with the whole concept, philosophy and look of the band.' Hits including 'Virtual Insanity' have racked up 26 million record sales.

Kent, Duke of

Prince Edward, Duke of Kent and father of Queen Victoria, made Ealing fashionable when he moved to Castle Hill Lodge on Castlebar Hill, in 1801. The house had extensive pleasure gardens covering the area between today's Castlebar Hill, Pitshanger Lane, Kent Gardens and Queens Walk, where there was a barracks for his guards.

The Duke of Kent, son of George III, lived where St David's Home is now.

The Duke of Kent pub, Scotch Common, is close to the duke's former home.

The Duke (1767–1820), fourth son of George III, bought the house from Maria Fitzherbert, who had lived here from 1795 after her marriage to his brother, the Prince of Wales, later George IV, was annulled. He lived here with his French-Canadian mistress, Julie de Saint-Laurent.

He left the house in 1812 and a new mansion, Kent Lodge, was built on the site in 1845. That house, extensively altered, is now the St David's Home for ex-service men and women.

Kinnock, Neil

The former Labour leader Neil Kinnock lived in Ealing with wife Glenys and children Stephen and Rachel during the period in which he fought and lost the general elections of 1987 and 1992.

Neil, who became an European Commissioner after quitting British politics, lived in Clovelly Road, W5. He entered the house of Lords in 2005.

L

Laine, Cleo

The jazz singer Cleo Laine spent much of her childhood in Featherstone Road, Southall. She was born in 1927 (as Clementine Dinah Bullock) to a very musical family. Her Black Jamaican father and White English mother were not married, and life was tough. Cleo's hard-up parents made great sacrifices to pay for music and singing lessons, in the hope her talent would be her escape from poverty.

She only took up singing professionally as an adult but, in 1958, at the age of twenty-four she auditioned for John Dankworth's group. Her near four-octave vocal range impressed, and she was hired. Dankworth fell in love with more than Cleo's voice, and they secretly married later that year.

The couple had stellar careers together and were honoured with a knighthood and damehood. Cleo also collaborated with Ray Charles, James Galway, Nigel Kennedy, Julian Lloyd Webber and John Williams. She was widowed in 2010.

Lammas Park

Lammas Park gets its name from Loaf Mass Day, the harvest festival celebrated on 1 August, when villagers were allowed to start grazing their animals on

Lammas Park gets its name from common grazing areas known as Lammas Lands.

designated common land known as Lammas Lands. Animals could be kept there until Candlemass, on 2 February. The tradition here ended in 1880 when the area became a public park.

Lytton, Lord

The novelist Edward Bulmer, Lord Lytton, close friend of Charles Dickens, attended a school on Haven Green in the early 1800s. He writes of an incompetent head teacher called Revd Charles Wallington who rose in the boys' estimation when he bought Black Bess, once the favourite horse of George III. The horse was trained to protect the king by trampling any stranger who grabbed her bridle while she was being ridden.

Lytton later returned to live in Acton at Berrymead Priory, previously known as Grove House, which stood off the High Street.

Lord Lytton, a hugely popular novelist, whose most successful book was *The Last Days of Pompeii*, was as famous for his *bon mots*. He coined the phrases 'the great unwashed', 'in pursuit of the mighty dollar', 'the pen is mightier than the sword', and the well-known and since much-parodied opening line 'it was a dark and stormy night'.

MacColl, Kirsty

The singer and songwriter best known for her duet on 'Fairytale of New York' with Shane McGowan of The Pogues lived at 48 Mount Park Road, W5, from 1985 until her untimely death in 2000.

The song is the most played Christmas track of the twenty-first century, according to the music licensing company PPL. Kirsty bought the house with her then husband, the record producer Steve Lillywhite. The couple divorced in 1997. Kirsty recorded her final album at the studio Lillywhite built there, which is now run by her partner, James Knight.

She was born in 1959, the daughter of 1950s folk legend Ewan MacColl, and had a string of hits including *There's a Guy Works Down the Chip Shop Swears He's Elvis* and cover versions of The Kinks' *Days* and Billy Bragg's *A New England*.

Kirsty died tragically, at the age of forty-one, when struck by a speedboat while swimming off the Mexican island of Cozumel.

Manor of Ealing

The ancient Manor of Ealing extended from the Thames north to Hanger Hill, and Ealing Manor House stood near the present Gunnersbury Park, but was demolished for roadworks in 1929. In 1547 the manor was leased by the Bishop of London to the Duke of Somerset for 200 years.

Somerset was the oldest brother of Jane Seymour, the only one of Henry VIII's six wives to bear him a son. Somerset virtually ruled the country as Protector when that son, as Edward VI, became king at the age of just nine. It didn't last. Somerset was executed in 1552, and Edward died the following year.

Market Gardening

Market gardening was the chief occupation in the area from the Middle Ages, with Ealing supplying London with much of its produce. In Northolt, Greenford and

Perivale, huge areas were put over to hay in the nineteenth century, to feed the capital's horses.

Marshall Amplifiers

Modern stadium rock concerts were made possible thanks to a little shop in Hanwell.

It all started when The Who's guitarist Pete Townshend wanted an amp strong enough to project his sound over the combined power of the drums and bass of fellow band members Keith Moon and John Entwistle, and raucous audiences, and turned to Jim Marshall.

Jim, a former dance band drummer and tutor who had played with Pete's dad, ran a musical instrument shop, Jim Marshall and Son, at 67 Uxbridge Road, Hanwell. Pete bought guitars and amps from the shop, but in 1962 complained that what was currently available didn't give him the tone and volume he needed. Jim Marshall and son Terry set about building their own amp to meet Pete's specification.

One Sunday night in 1963 the Marshall JTM45 amp they came up with was tested at the Ealing Club (see separate entry) in a band featuring the future Jimi Hendrix Experience drummer Mitch Mitchell, who was once tutored by Jim and worked in his shop.

Guitarists and bands including Jimi Hendrix, Eric Clapton, Ritchie Blackmore, Slash, Oasis, Muse and Gorillaz went on to use Marshall amps. Great stacks, or walls,

 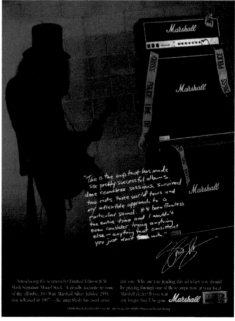

Above left: Jim Marshall invented his world-famous amplifiers at this little shop in Hanwell.

Above right: Guitarists including Slash of Guns N' Roses have endorsed Marshall amps.

of Marshall amps were seen on stages, in stadiums and at festivals. Jim was credited with making huge musical events possible, and became known as the 'Father of Loud' or the 'Lord of Loud'.

He died in 2012, at the age of eighty-eight, but the Marshall name lives on. Now based in Bletchley, the company is still a leading manufacturer of amps, and has branched out to produce headphones, and open a record label.

McQueen, Steve

The award-winning director of *Twelve Years a Slave* grew up in Hanwell. The film won the Best Picture Oscar in 2014. Sir Steve McQueen went to Little Ealing Primary School and Drayton Manor High School, Hanwell, transferring to Ealing, Hammersmith and West London College to study A-level art. He continued his art education at Chelsea College of Arts, Goldsmiths College University of London, and at New York University's Tisch School of the Arts, developing his interest in film. He won the Turner Prize in 1999 and was knighted in 2020.

Sir Steve revisited his Ealing schooldays when he collaborated on a project, *Year 3*, to photograph all 76,000 seven-year-old pupils in London's schools and present the extraordinary diversity of the city's population. Over 3,000 photographs of the children were posted on 600 billboards around the Capital, and an exhibition held at Tate Britain in 2019–21.

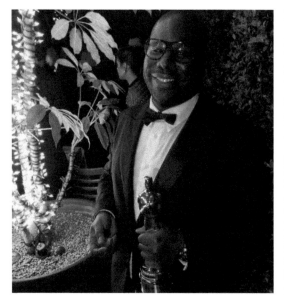
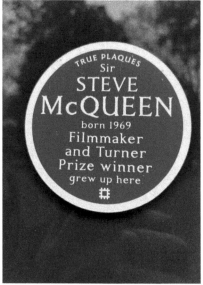

Above left: Steve McQueen won an Oscar for *Twelve Years a Slave*.

Above right: McQueen's Ealing connection is honoured around the borough.

M

Middlesex

Ealing was once in the county of Middlesex, an administrative area established in 740 by the Anglo Saxons, the name a reference to the Middle Saxons who lived here. It was bounded to the south by the River Thames, to west and east by the rivers Colne and Lea, and to the north by the ridge that formed a watershed between the rivers Brent and Colne, running from Harefield to Elstree, then north of Enfield to Waltham Abbey.

Middlesex is described, in the *Oxford Companion to British History* as 'one of the smallest, oldest and strangest of counties'.

It ceased to be an official county and administrative area under local government re-organisation in 1965, when almost all its geographic area was incorporated into Greater London. However, the name is still used in, for example, the Middlesex County Cricket Club (MCC), Middlesex University, and Central Middlesex Hospital.

Around 20 per cent of its area had already been lost, in 1889, when county councils were introduced, and the administrative County of London was formed alongside Middlesex County Council.

The former county is celebrated by John Betjeman in his poem, *Middlesex*, in which he praises areas including Perivale and Greenford:

Parish of enormous hayfields
Perivale stood all alone,
And from Greenford scent of mayfields
Most enticingly was blown
Over market gardens tidy'

Montague, Lady Mary Wortley

The woman who introduced smallpox inoculation to England lived in Grove House, Acton. Lady Mary (1689–1762), eldest daughter of Evelyn Pierrepoint, Duke of Kingston upon Hull, eloped from the house and fled to Constantinople, where her husband was ambassador.

During her travels in the Ottoman Empire she witnessed the use of inoculation to tackle the disease. Lady Mary had been disfigured by smallpox and her brother died from it. Determined to protect her four-year-old son, she had him inoculated, a process which in those days involved introducing live smallpox virus, using pus from a mild smallpox blister, into a scratch in the skin of the patient.

In 1721, after her return to England, a smallpox epidemic erupted. Lady Mary loudly advocated inoculation, and had her daughter treated – the first person inoculated in this country – but there was fierce opposition to what was considered a quack folk remedy.

Lady Mary persuaded the Princess of Wales, Caroline of Ansbach, to be inoculated and seven condemned prisoners in Newgate were offered the process. They were told they would escape execution if they survived. They did, and were released.

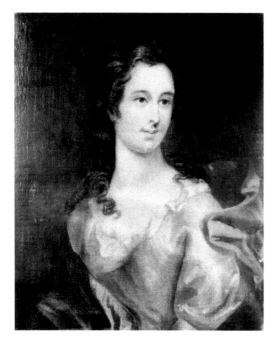

Left: Lady Mary Wortley Montague introduced smallpox inoculation to England. (Wellcome Collection)

Below: Lady Mary had her daughter inoculated to prove the procedure was safe. (Wellcome Collection)

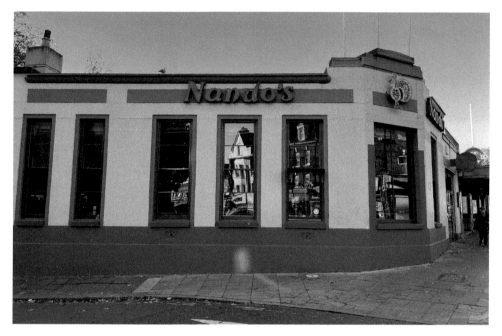

The spicy chicken chain Nando's opened its first UK branch at Ealing Common.

Nando's

The South African spicy fried chicken chain opened its first UK restaurant in 1992 beside Ealing Common underground station on the Uxbridge Road, W5. There are now 340 in the UK, and around 900 globally, and the first English branch is still in business.

Nash, John

The distinguished architect John Nash was granted permission to dig clay for bricks used to renovate Buckingham Palace at what is now Bixley Field allotments in Merrick Road, Southall.

Permission was granted by the landowner the Earl of Jersey in 1826 to quarry clay for some of the many millions of bricks required to fulfil George IV's ambition to turn the then Buckingham House into a palace.

Nash, who held the title Official Architect to the Office of Woods and Forests, spent five years and £.5 million (£500 million today, according to the Bank of England's inflation calculator) creating the imposing U-shaped building with wings enclosing a grand forecourt with triumphal arch.

Southall bricks contributed to what was judged a masterpiece, but when the king died in 1830 Nash was deemed to have overspent, and was fired by the prime minister.

North Korean Embassy

A discreet sign, and national flag on its flagpole, identify the seven-bedroom detached house at 73 Gunnersbury Avenue, W5, as the North Korean Embassy.

The house briefly made the headlines in 2016 when, after a decade enjoying life in Ealing, deputy ambassador Thae Yong-ho defected to South Korea along with his family.

In an interview with the BBC after his escape to Seoul, Thae spoke fondly of the friendliness of the people of Ealing, and in particular of the members of the St Columba's Tennis Club, just across the road from the embassy, who he said he would miss greatly.

Thae Yong-ho was responsible for promoting the image of his country in Britain and when, in 2014, an Ealing barbers was seen to have insulted the leader, Kim Jong-un, he protested. M&M Hair Academy in Venetia Road had a poster of the leader in the window above the line 'Bad Hair Day?'. They were asked to remove it, but declined.

Another of his tasks had been to escort Kim Jong-un's brother to an Eric Clapton concert in the Albert Hall.

The North Korean Embassy in
Gunnersbury Avenue, W5.

O

Only Fools and Horses

Mandela House, the tower block in which Del Boy and Rodney Trotter live in *Only Fools and Horses*, is actually in Acton, rather than Peckham where the BBC sitcom was set, and is named Harlech Tower. Exterior shots of the thirteen-storey block, in Park Road on the South Acton Estate, were used in the opening credits of the show from 1981 to 1985, after which a block in Bristol was used. It also featured in a prequel spin-off, *Rock & Chips*, filmed in 2009–10 but set in 1960.

Harlech Tower, built in 1968, was scheduled for demolition in 2019, but is still standing with destruction now scheduled for 2025. David Jason, who played Del Boy in the show, called for a preservation order to be placed on it. He said: 'Of course I think it should be a listed building. What a shame. But they are not going to listen to me, are they?'

The South Acton Estate is being redeveloped by Ealing Council, and is now known as Acton Gardens.

Some other scenes were shot in Ealing. In an episode called 'Go West Young Man', Del and Rodney crash car dealer Boycie's Jaguar outside Ealing Dance Centre at

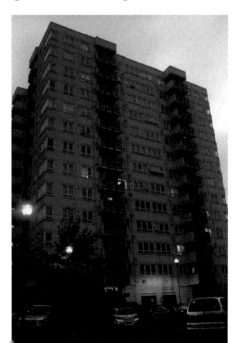

Mandela Tower in *Only Fools and Horses* is actually Harlech Tower in Acton. (Phillip Perry under Creative Commons)

98 Pitshanger Lane. The Cafe Rosetta in St John's Parade, Mattock Lane, W13, featured as Sid's Cafe in an episode called 'The Long Legs of the Law'. The cafe was also used in the 2009 film *An Education*, starring Carrie Mulligan.

Organ Factory

Organs for hundreds of cinemas, churches and a few cathedrals were built by the John Compton Organ Company of Acton.

There was huge demand for John Compton's powerful and highly innovative electric organs from the many grand picture palaces opening in the 1920s and 1930s, and 270 were produced by the 250 employees of what was the largest organ builder in the country.

Compton's most famous cinema organ is at the Odeon, Leicester Square, where it rises from a pit beneath the stage for film premiers, its multi-coloured illuminated console sparkling under the spotlights.

However, John (1876–1957) had established his firm in 1920 to build, repair and tune traditional church organs. He built notable electric-action pipe organs for Downside Abbey, Derby Cathedral and St George's Roman Catholic Cathedral, Southwark, and – locally – for Ealing Abbey in Charlbury Grove, W5, Pitshanger Methodist Church in Pitshanger Lane, and the Church of the Ascension in Beaufort Road, close to Compton's home.

The business originated in Nottingham and moved to Turnham Green Terrace in Chiswick, then to a purpose-built factory in Chase Road, Park Royal, in 1930. John lived close by for twenty-seven years, at 37 Audley Road on the Hanger Hill estate.

The original single-storey factory was bombed in 1940 and rebuilt with two storeys, and still stands. During the Second World War it switched to making Mosquito planes, but Compton was not there. He had been arrested as an enemy alien on the Italian island of Capri while on holiday, and spent the war restoring pipe organs and playing for the community.

The company only survived for a few years after Compton's death. Ealing Civic Society placed a green plaque to Compton on his former home in 2013.

Hundreds of church and cinema organs were made by John Compton in Acton. (Alex Smith under Creative Commons)

P

Perceval, Spencer

The only British Prime Minister to be assassinated lived alongside Ealing Common in a house that passed its name to a street: Elm Grove Road.

Spencer Perceval (1762–1812) was shot dead in the House of Commons, at the age of forty-nine, by a bankrupt Liverpool businessman, John Bellingham, who held the government responsible for a failed business venture in Russia. Bellingham was immediately tried and hanged within seven days of the murder.

Perceval, after whom Ealing Council's main office block on Uxbridge Road is named, lived in Elm Grove with his wife Jane and twelve children, and made his final journey to the Commons from the house. A substantial lump sum and pension paid by the state enabled Jane and children to continue living at the mansion after her husband's death, and she subsequently married Col Henry Carr, the son of Ealing's vicar.

After Jane's death, her four unmarried daughters moved in to Pitzhanger Manor, becoming known as 'the ladies of the manor house' and true Ealing celebrities. When

All Saints Church, built in memory of Spencer Perceval, the only British prime minister to be assassinated.

Spencer Perceval's assassination, as depicted in a contemporary newspaper report.

the final Perceval daughter, Frederica, died in 1900 at the age of ninety-five, she left money in her will for a church to be built in her father's memory. All Saints was built on the site of the Perceval family home, and now bears a plaque recording the connection with Spencer Perceval. The church's dedication is inspired by the fact that Perceval was born on 1 November, All Saints Day.

Perry, Fred

Fred Perry, the last male English player to win Wimbledon before Andy Murray's triumphs in 2013 and 2016, learned to play lawn tennis at the Brentham Club in Meadvale Road, W5, and attended Ealing Grammar School for Boys on Ealing Green, now West London College.

Perry (1909–95) was born in Stockport, but his family moved to Brentham Garden Suburb when he was eleven. The move occurred when his father became national secretary of the Co-operative Party. He later became MP for Kettering.

Perry's first sport was table tennis, at which he also excelled, becoming World Champion in 1929. He began playing lawn tennis at the age of fourteen, taking it seriously at twenty-one, and went on to win three consecutive Wimbledon Championships from 1934 to 1936, during which time he was World Amateur number

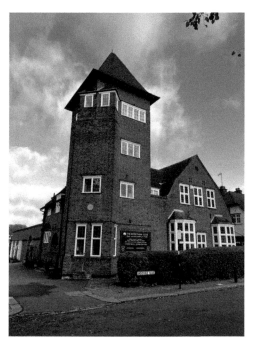 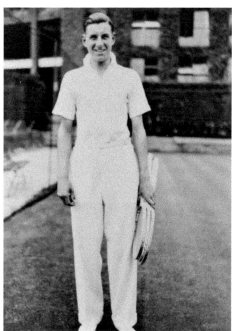

Above left: Fred Perry learned to play lawn tennis at the Brentham Club in Meadvale Road.

Above right: Fred Perry, the last Englishman to win Wimbledon before Andy Murray's triumphs in 2013 and 2016.

one tennis player. Among many other achievements, he was the first ever player to win a Career Grand Slam, taking all four singles titles at the French Open in 1935.

A statue of Fred was unveiled at Wimbledon in 1984.

Pitzhanger Manor

Sir John Soane's country house in Ealing is much prized by the town today, and was a great professional triumph for the architect responsible for the Bank of England and Dulwich Picture Gallery.

Soane's personal identification with Pitzhanger Manor led him to describe its facade, in a lecture to the Royal Academy, as being his architectural self-portrait.

However, there is also a story of profound personal disappointment attached to this house. Soane found life here so blighted that, within seven years, it was up for sale.

When he began the project in 1800, Soane had envisaged the house, the 28-acre grounds of which are now Walpole Park, only partly as a place in which to give full expression to his architectural vision. It was also to be a fitting home for his extensive collection of art and antiquities, historical books and architectural models, furniture

Pitzhanger Manor, country home to the architect Sir John Soane.

and decorative arts. Most importantly, he hoped to found here a family dynasty, expecting his sons John and George to continue his architectural practice at the house.

His connection with the existing house on the site, which he bought in 1800 and spent four years transforming, stretched way back to the time when, as a fifteen-year-old apprentice to the distinguished architect George Dance, it was the first project he worked on.

Looking back in 1832, he wrote: 'My object in purchasing these premises was to have a residence for myself and family, and afterwards for my eldest son, who at an early age had ... shewn a decided passion for the fine arts, particularly architecture, which he wished to pursue as a profession ... I wished to make Pitzhanger manor-house as complete as possible for the future residence of the young architect.'

While demolishing much of what stood here, Soane retained a two-storey wing – with dining room below and drawing room above – which he had worked on, and which he deemed 'exquisite in taste, and admirable in execution'.

It is nowhere near as impressive, however, as the new portion, with its internal lobby illuminated from above by a lantern of amber stained glass, and rooms painted to resemble a range of marbles.

Soane tasked John with designing some mock-Roman ruins that he planned to place beside the house. When John failed to produce the sketches his father had asked him to come up with, having decided architecture was not for him, Soane was mortified. His wife Eliza expressed 'regret that we were ever possessed of Ealing'.

In 1900, the house – on Ealing Green, W5 – was bought by Ealing Urban District Council, and housed Ealing Public Library from 1939 to 1984. In 2015, Pitzhanger closed for three years while the Grade I listed building was restored, following Soane's original designs.

Plague

Many Londoners fled the Plague of 1665 for the fresh air of Ealing and Hanwell. The villages became affectionately known, respectively, as 'H-ealing' and 'An(d)well'.

Polish Community

Ealing has the largest Polish community in the country, with the 2011 census recording 21,507, or 6.4 per cent of residents identifying as Polish. The first arrivals settled here after the Second World War, some having served with the expatriate Polish Air Force during the conflict, and stationed at Northolt Aerodrome.

The Polish War Memorial was established near the aerodrome in 1948, honouring 1,243 Poles who died in the war, with a further 659 names added when the memorial was refurbished in 2010.

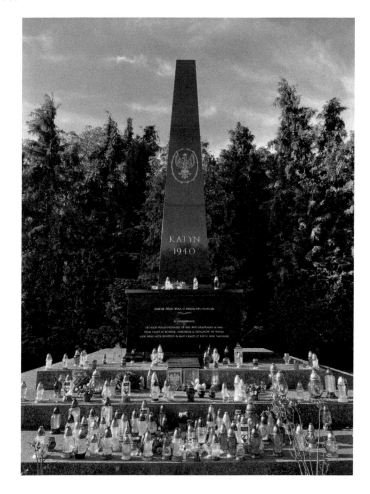

The monument to the Katyn massacre of 1940 in Gunnersbury Cemetery.

There is a more controversial memorial to Polish dead in Gunnersbury Cemetery in Gunnersbury Avenue, W3. It remembers victims of the Katyn massacre of 1940, in which 22,000 Polish soldiers and intellectuals were slaughtered by Soviet secret police, the NKVD. It was the first such memorial in the world, and official opposition to it delayed the project for several years.

At the time the memorial was unveiled, in 1976, the Soviet Union was still denying responsibility for this war crime, and no official representative from the British government attended the ceremony. It was not until 1990, after the fall of Communism, that the Russian government abandoned claims that the Nazis had carried out the atrocity, and accepted Soviet secret police were responsible.

Public Baths

Public baths once stood behind Ealing Town Hall in Longfield Avenue, with three pools designated First, Second and Third Class. Prior to this, poorer residents used a natural bathing pond near Ealing Common, formed by a spring that rose in the grounds of Elm Grove. Acton Swimming Baths, built in 1904 as part of the town hall and library complex, closed in 2011 for a £13 million three-year redevelopment project, in which the original pool was replaced with a new 25-metre eight-lane pool and a smaller teaching pool.

Queen of the Suburbs

That Ealing became known as the Queen of the Suburbs is largely due to Charles Jones, the borough's dynamic architect, engineer and surveyor who was known as the 'man at the wheel'.

Jones (1830–1913) held the three posts for fifty years, transforming the borough. Its regal status was built on solid foundations. Jones established the first comprehensive sewage system in the Thames Valley; paved and lit the existing roads, and laid new ones; and established an electricity generating station.

The monument to Charles Jones, mastermind of Ealing's development, in Walpole Park.

Ealing's Gothic Revival town hall is one of Charles Jones's finest creations.

He ensured high-quality development through tight controls on developers, insisting that good roads be completed before construction began, leading to a substantial increase in property values. He also developed property for his own profit, including on the site of Kent Lodge in Castle Bar, competing with housing associations seeking to build affordable housing for the working classes (see entry for Brentham Garden Suburb).

Jones instilled civic pride by designing the imposing Gothic Revival town hall on New Broadway, and the adjoining Victoria Hall function room, negotiating to buy the land at a knock-down price in return for a Deed of Covenant, under which it would remain council property and a public building in perpetuity. He adapted Pitzhanger Manor to house Ealing's first public library.

Jones designed churches, including the Congregational Church (now United Reformed and Methodist) on Ealing Green, and the Methodist (now Polish Roman Catholic) church on the corner of Windsor Road and Uxbridge Road. He was responsible for the first state primary schools, including those serving Drayton Green, Little Ealing, Northfields, and North Ealing Primary in Pitshanger Village.

He bought land to create Walpole and Lammas Parks, and had the distinctive avenues of horse chestnut trees planted on Ealing Common. After he retired, in his eighties, the town asked him to be their next mayor but, sadly, he died before he could take up the post. There is a memorial to him in Walpole Park and a plaque on his house, No. 5 Windsor Road, W5.

Questors Theatre

Questors in Mattock Lane, W5, is the most professional of amateur theatre companies, staging around twenty productions a year, and boasting distinguished presidents: Sir Michael Redgrave in 1958–85 and Dame Judi Dench since then.

Among the theatrical figures associated with it is the playwright Sir Tom Stoppard, whose *Rosencrantz and Guildenstern Are Dead* started out as a one-act play staged by the Questors company, first in Berlin and then in Ealing.

The company was established in 1929, and its present theatre built in 1964 on the site of a house called Mattock Lodge. The house had been owned by Fr Richard O'Halloran, a priest who established a Catholic church in the grounds.

When Cardinal Vaughan instructed him to hand over his parish to the Benedictines, who founded Ealing Abbey in Charlbury Grove, W5, in 1897, he refused. An unseemly row broke out which the Benedictines finally won, and the church closed.

O'Halloran left his property to Miss Ann Webb, and in 1933 Questors was invited to share the former church premises with Ealing Boy Scouts. After Miss Webb's death, in 1952, Questors bought the freehold of the whole site.

Questors Theatre in Mattock Lane, of which Dame Judy Dench is president.

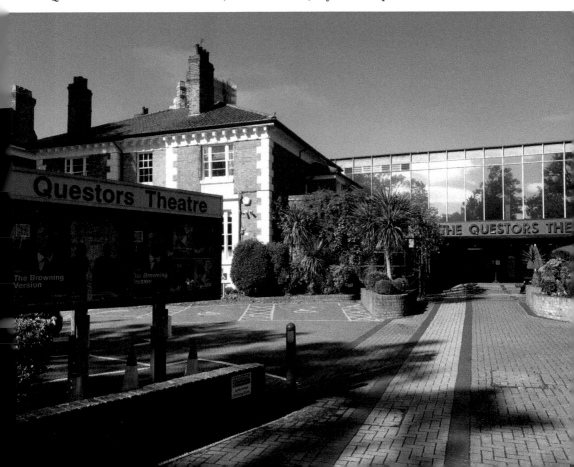

Racecourse

Northolt Park Racecourse was intended to be a premier course for London's pony racing enthusiasts when it was established in 1928 but, despite the 1938 Northolt Derby being televised by the BBC, it failed to catch on.

The 1.5-mile course was part of efforts by the Pony Turf Club to reform pony racing, which was notoriously corrupt, and establish it as a legitimate sport. Northolt was chosen as the national headquarters of the club.

The racecourse was founded on a 147-acre site bounded by Mandeville Road, Eastcote Lane, and Dabbs Hill Lane, Northolt. At the time this was a completely rural area, but served by a small halt, now Northolt Park, on the Great Western Railway line from Paddington, which gave easy access from the Capital.

The sum of £250,000 (£8 million today) was spent, a large chunk of it on an elegant modernist grandstand, featuring the first cantilevered roof in Britain, and the largest in Europe, with an overhang of 66 feet, ensuring racegoers kept dry. Another innovation was the first live commentary relayed via a tannoy system in 1937, a full fifteen years before mainstream Jockey Club horse racing courses adopted the idea. Next year the BBC televised the Northolt Park Derby race, only the second live broadcast of a race in this country.

Sadly, income at the course did not cover the enormous outlay of establishing it, and bankruptcy loomed. The Second World War saw the suspension of racing, and in 1946 the course was sold for housing.

Ravilious, Eric

Eric Ravilious, the artist most famous for his stark landscapes and war scenes, was born in Acton in 1903, where his father, Frank, an upholsterer and cabinetmaker, had a shop at 5-6, The Parade, now No. 96 Churchfield Road, W3.

Another branch of the Ravilious family had a shop selling hats, hosiery and clothing elsewhere in the street. Eric's family moved to Eastbourne when he was a child.

Ravilious died in 1942 when his plane was shot down over Iceland while he was on active service as a war artist.

Richards, Frank

Charles Hamilton, the creator of Billy Bunter, who wrote as Frank Richards, was one of eight children born in a modest terraced house at No. 15 Oak Street, Ealing. The house was demolished when the network of streets to the south of the Uxbridge Road made way for the Ealing Broadway Centre, but a blue plaque on the Pandora jewellery shop marks the spot.

Hamilton's father, John, was a journalist who died in 1884, when Charles was seven, threatening financial ruin for the family. Fortunately, his mother Marion's brother Stephen Trinder, a local estate agent, saw that the family was housed, but moves were frequent and money short.

Perhaps it is telling that one of the characteristics of Billy Bunter, Hamilton's most famous creation, is that he exaggerates his parents' wealth, and elevates their modest suburban villa into Bunter Court, a country house with imposing facade and vast acres.

Charles, finding he had a talent for storytelling, set about writing himself out of his humble origins. He instantly found success, at the age of seventeen, in the rapidly expanding market for boys' periodicals. A literary agent called Dowling Maitland bought his first story, and subsequent efforts, for five guineas (working men earned £2 a week at the time), but reduced the fee to £4 once he had met Hamilton and discovered how young he was.

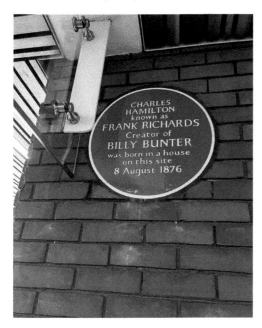
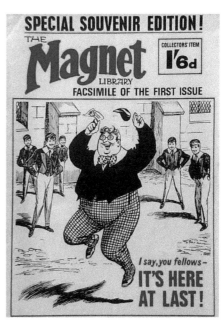

Above left: Charles Hamilton, creator of Billy Bunter, was born in a house demolished to make way for the Ealing Broadway Centre.

Above right: Billy Bunter stories first appeared in Magnet and other periodicals.

From 1905 Hamilton specialised in school stories, for *The Magnet*, *The Gem* and other periodicals. His incredible work rate – churning out 100,000 words a week, 7.2 million in his lifetime, equivalent to over 1,000 novels – makes him the most prodigious author ever.

In addition to stories about Greyfriars' School and Billy Bunter he wrote, under at least twenty-seven further aliases, a whole range of other accounts of public school life, and boys' and girls' adventure stories.

Rothschild

The Rothschild banking family has had a significant influence on the development of Ealing.

The merchant and financier Nathan Mayer Rothschild bought the Large Mansion in Gunnersbury Park, now a museum, in 1835, and the adjacent Small Mansion and grounds were added by his descendent Leopold in 1889.

The family also bought extensive stretches of land in the area, including the 200 acres of Old Brentford Common Field to the west, now Gunnersbury Park, and stretches of land to the north. In 1894 Leopold developed 35 acres alongside Ealing Common at Elm Grove, demolishing the house once lived in by Spencer Perceval (see separate entry), and donating land on a plot where All Saints Church was built in the assassinated prime minister's memory.

Several present-day features of Gunnersbury Park were established during Rothschild ownership, including the Orangery, and the transformation of an old clay pit into the Potomac Lake.

Below and opposite: Nathan Rothschild and his descendants created a grand house with lake and orangery at Gunnersbury.

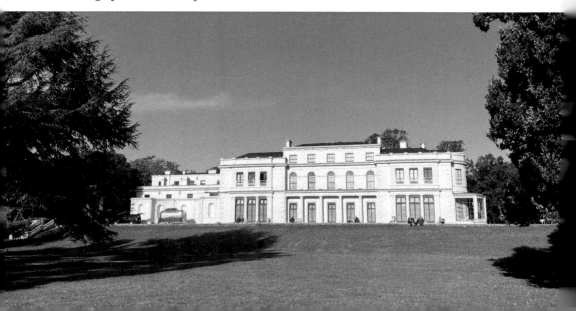

The estate was sold in 1925 to the then separate Ealing and Acton councils, despite it lying outside their areas, to prevent it being bought by Brentford council and used for municipal housing. The park, now owned jointly by Ealing and Hounslow councils, has recently undergone extensive £50 million restoration of buildings and park. The Large Mansion is fully restored as a museum, and work is underway on the Small Mansion. Extensive sporting facilities have been developed, and the park is a hugely popular recreation spot with residents.

Sixteen String Jack

Notorious highwayman John Rann, better known as Sixteen String Jack, was captured after holding up the chaplain to Princess Amelia (daughter of George III) in 1774 on Gunnersbury Lane, W3, and executed at Tyburn, wearing the pea-green suit with eight silver strings on each knee that gave him his nickname.

Smart, Billy

The greatest circus impresario Britain has ever produced came from Ealing. Billy Smart (1894–1966) was one of twenty-three children born to the owner of Smart's Removals, which still exists today as Smarts of Northolt, based in Derby Road, Greenford.

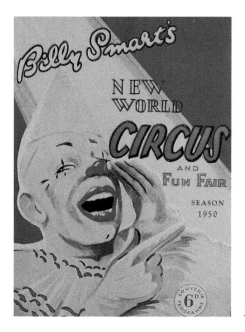

A 1950 poster advertising Billy Smart's Circus.

The family also ran a small funfair and, at the age of fifteen, Billy made his debut as a showman operating his father's hand-cranked roundabout at a fairground in Slough.

In 1925 Billy married Nelly Rigby – known as Doll or Dolly – and established his own funfair and, by the late 1930s, had one of the largest travelling fairs in the country, assisted as they grew old enough by each of his ten children.

In 1946 Billy realised his ambition to run a circus, buying a second-hand big top. The grandly named Billy Smart's World Circus made its debut in Southall Park, running alongside the funfair, but within six years it had proved so successful that the funfair element was dropped.

In 1955 a new, 6,000-seater big top was introduced, with a track around the central ring that allowed parades, Wild West shows and other spectacles to be added to the repertoire. The circus toured the country with forty horses, fifteen elephants, lions, camels, seals, and polar bears. However, by 1971 the enormous cost of keeping such a huge enterprise on the road brought the end of touring with the big top. Fortunately, by then, television offered a lifeline.

The BBC had been broadcasting television specials from the circus since 1947, including an annual Billy Smart's Christmas Spectacular which ran until 1979, switching to ITV for a further three years. In 1977 the Queen and Prince Philip attended the Royal Jubilee Big Top Show, held to mark Elizabeth's quarter century on the throne.

After Billy's death in 1966, his sons Ronnie, David and Billy Jr ran the business.

In 1993 Ronnie's sons launched a short-lived revival of the touring show. Then, in 2011, Gary Smart launched Billy Smart's New Circus, in a much smaller 1,400-seat big top. By then, only domestic animals could perform, but many local authorities would not even allow horses or dogs, which limited touring opportunities.

Southall

Southall's large Asian community, numbering over 75 per cent of the local population, has established a vibrant town. The first south Asians to arrive, in the early 1950s, came to work in a factory, and were hired by a former British Indian Army officer.

The R. Woolf rubber and tyre factory, which opened in 1951 at Hayes Bridge in Southall, sought workers from the Punjab, where the general manager had served with Sikh soldiers during the Second World War.

The Punjab, an area with Sikh, Hindu and Muslim communities, was partitioned by the British in 1947, and its territory split between India and Pakistan. All three communities came to London, but the majority were Sikhs. Within a decade Southall would become the country's premier Asian town, dubbed Chota Punjab – Little Punjab.

The first arrivals settled around Aldgate, East London, but began renting rooms close to the factory. They were hired to do the very dirty labouring jobs that indigenous

Southall's Gurdwara Sri Guru Singh Sabha temple. (Gurdwara HDR under Creative Commons)

workers were reluctant to do. Graham Stevenson, author of *Migrants & the TGWU*, writes: 'Working conditions were unpleasant and Indian workers were only taken on for labouring jobs at lower wages than white colleagues doing similar jobs.'

In 1965, 600 Asian workers went on strike, demanding safer working conditions, only to be locked out for seven weeks. As a result unionisation spread, and conditions gradually improved.

A Southall Punjabi was also responsible for introducing the Asian-run corner shop to Britain. The very first of these opened in 1954, run by Pritam Singh Sangha, sparking a consumer revolution. *The Guardian* reported:

> When a shipment of provisions arrived from India, Sangha would dispatch his daughter Guddi to spread the good news. Scurrying from house to house, her arrival was always greeted with delight because it meant that larders could be replenished with food staples that doubled as a reminder of home.
>
> 'The shelves emptied as rapidly as they had been stocked with spices, chapatti flour, lentils and other products not available anywhere else: Britain's love affair with curry was still several years away.

More recently, Southall has become home to Afghan, Sri Lankan and Somali communities.

Southall Horse Market

For 309 years Southall had a thriving livestock market, but in 2007 a history stretching back to 1698 was ended.

Horses, cattle and pigs were sold each Wednesday at a yard just off the High Street, and a general market held every Wednesday and Saturday. The latter still thrives, with a bric-a-brac and general goods market on Fridays.

Southall was a village with a population of just 697 when, in 1698, Francis Merrick gained permission from William III to hold cattle auctions. In 1805 William Welch created a purpose-built cattle market.

The horse aspect of the market became increasingly famous as the number of other such markets diminished in the nineteenth century, attracting horse dealers and travellers from a wide area.

Michael Lovelace, from the firm that ran the market, told *Horse and Hound* magazine that the retirement of his two partners, Richard Steel, eighty-nine, and Anthony Lovelace, seventy-seven, led to the market's closure.

The magazine reported:

> Over the years the market has attracted criticism for its standards of welfare, but Sharon Edwards, animal health inspector for the City of London Corporation, said the market didn't deserve its bad reputation.
>
> 'I've been going for 12 years,' she said, 'and have never had reason to make a prosecution. If an animal was not fit for sale we'd withdraw it but that only ever happened on a couple of occasions.'
>
> The sentiment was echoed by Allison Williment, field officer for the International League for the Protection of Horses, who said she had never needed to intervene in the auctions.

Approval was given in 2019 for the horse market site to be developed for housing.

Springbridge Road

Springbridge Road, W5, which runs north from Ealing Broadway alongside Haven Green, is so named because of a spring that emerged from a source on Castlebar Hill. The stream, which ran down to the road, was diverted into a culvert when the area was developed.

Springfield, Dusty

Mary O'Brien, who gained fame as Dusty Springfield, grew up in Ealing. Her family moved to Kent Gardens, W5, from West Hampstead when she was eleven, and she

Above: Ealing Fields High School was St Anne's Convent when Dusty Springfield attended.

Left: Dusty Springfield. (Anefo under Creative Commons)

attended St Anne's Convent, now Ealing Fields High School, in Little Ealing Lane, from 1951 to 1955.

She was given the nickname Dusty by the boys she played football with in the street.

At the age of twelve, Dusty recorded Irving Berlin's *When the Midnight Choo-Choo Leaves for Alabam'* in a booth at an Ealing record shop. After leaving schools she worked in Bentalls, in Ealing Broadway.

Dusty (1939–99) had a remarkable career in which her wonderful mezzo soprano was applied to great effect on blue-eyed soul, pop, dramatic ballads, country and jazz. With her brother Tom and friend Tim Field she formed The Springfields, and had hits in the UK, America and a No. 1 in Australia. The band split in 1963 and Dusty had huge solo success here and in America, with songs including 'I Only Want to Be with You', 'Son of a Preacher Man' and 'You Don't Have to Say You Love Me'. She was the first British female vocalist inducted into the US Rock 'n' Roll Hall of Fame.

Her peroxide blonde beehive hairstyle, thick black eyeliner and eyeshadow, and evening gowns helped make her a swinging sixties icon. Three wigs helped achieve her look, each named after a fellow singer. There was Cilla (after Cilla Black), Sandie (after Sandie Shaw), and Lulu.

Sadly, Dusty died of breast cancer at the age of fifty-nine, in her adopted home of California.

Suicide Spot

A Victorian house called Eberslie Towers at 16 Montpelier Road, W5, became a notorious suicide spot. In 1887 twelve-year-old Anne Hinchfield leapt from the high tower that gave the house its name, and nineteen further suicides occurred there over the following half century. Perhaps the most shocking was the case of the nurse who threw a child from the tower before jumping to her own death.

The house lay empty until requisitioned by Ealing council in 1944 to store furniture salvaged from bombed houses and shops in the area, and workmen complained of strange noises, powerful invisible forces and a foul smell that pervaded the place.

Kate McEwan writes, in *Ealing Walkabout:*

> The ghostly face of a little girl at one of the windows was also seen on several occasions and was even photographed by parapsychological consultant Andrew Green ... the child must have been extremely tall for her age, as her shadowy features appear to fill the upper half of the window.

Eberslie Towers was demolished, and Elgin Court built on the site.

Three Bridges

The Three Bridges in Hanwell, where canal, road and rail all pass each other at a three-level crossing, was an engineering triumph for Isambard Kingdom Brunel.

He began the project in 1856, first sinking the line of his Great Western and Brentford Railway into a cutting – with the added advantage of obscuring it from the stately home of the Child banking family, at Osterley Park. Above this ran the Grand Junction Canal and, on top, Windmill Lane.

Road, rail and canal cross at the Three Bridges junction in Hanwell.

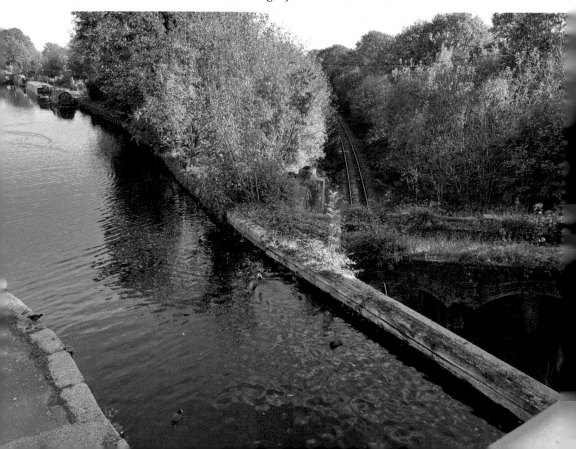

Three Bridges was an engineering triumph for Isambard Kingdom Brunel.

Work was completed in 1859, shortly before Brunel died on 15 September, making it the last project completed by the greatest engineer of the Industrial Revolution, famous for the Clifton Suspension Bridge, Paddington Station, steamships, dockyards and many other enterprises.

Townshend, Pete

As the home of Pete Townshend, Ealing played a formative part in the development of one of the greatest British rock bands, The Who.

On a Sunday night in Summer 1959, Acton County Grammar School (now Acton High) pupils Pete Townshend and John Entwistle played their first gig, as members of The Confederates, at the Congregational Church Hall in Churchfield Road, Acton. At the time Pete played banjo, but shortly afterwards switched to a £3 acoustic guitar bought from a junk shop, Miscellania, at Ealing Common. Pete lived with his parents at 20 Woodgrange Avenue, just to the east of the common.

Another step forward came when Entwistle bumped into Roger Daltry, who had been in the year above him and Pete at school. Roger was an apprentice sheet metal worker at Chase Products, 27 Packington Road, South Acton, and played guitar in a band called The Detours. John was invited to join the band as bassist, and Pete later joined on guitar.

The Detours played clubs, weddings and other gigs in the area, including the Jewish Youth Club at 15 Grange Road, W5.

Following school, Pete enrolled at Ealing Art College (now the University of West London in St Mary's Road, W5) and moved – at the age of sixteen – to a flat at 35 Sunnyside Road. Among his flatmates was Richard Barnes, who is credited with giving The Who their name, when he suggested it as an improvement on The Detours.

Other flatmates were Americans Tom Wright and Campbell 'Cam' McLester, who introduced Pete to American jazz, soul and R&B – and marijuana, a rarity in England at the time – further big influences on The Who.

The inspiration for smashing his guitar on stage also dates from Pete's days at Ealing Art College. The idea was born when Townshend attended a lecture there by Gustav Metzger, a German-born conceptualist and advocate of auto-destructive art. At another lecture, jazz bassist Malcolm Cecil sawed a double bass in half.

Left: Pete Townshend lived at 35 Sunnyside Avenue while a student at Ealing Art College.

Below: The Who's Roger Daltry and Pete Townshend met as Acton schoolboys. (Kubahe under Creative Commons)

U

Universities

There is one university – the University of West London – in the borough, but another, Brunel University in Uxbridge, has its roots here. Brunel started life as Acton Technical College, established in Acton High Street, in 1928.

In 1957 the college was split into two, with Acton Technical College continuing to train technicians and craftsmen, and the new Brunel College of Technology, named after Isambard Kingdom Brunel, training chartered engineers. From new premises, just off the High Street in Woodlands Avenue, it pioneered the concept of the sandwich course, in which students spent a period working in local industry.

In 1960 it was decided to seek new premises for Brunel College of Technology, where it could expand, and the Uxbridge campus was developed. The college achieved university status in 1966. It used both locations until 1971, when the Acton campus closed.

A prospectus for Acton Technical College, which became Brunel University.

V

Villages

In the centuries before Ealing became a sweeping Victorian suburb, this was a rural area dotted with villages whose names have survived to denote districts within the borough: Little Ealing, Ealing Dean, Haven Green, Drayton Green and Castlebar Hill among them.

Ealing Village was built in the 1930s as a mini Hollywood.

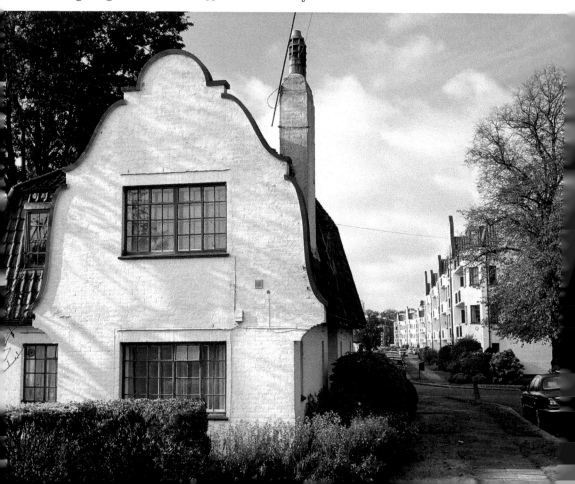

However, there is one village that is not ancient at all. Elegant, Dutch Colonial art deco-style Ealing Village was built in the 1930s as a mini Hollywood, in the hope of attracting film stars making movies at Ealing Studios as short-term residents.

The development, on Hanger Lane to the south of Madeley Road, was given a gated entrance guarded by twin porters' lodges. It included a clubhouse, swimming pool, tennis courts and bowling green, on a surprisingly rural-feeling enclave in this urban setting. Most of these facilities survive.

The 128 flats in five four-storey blocks were developed in 1934–36. The striking design – with white rendered external walls, decorative features picked out in red, and green-tiled roofs – won Grade II listing in 1991. Originally, flats were only available to rent, until purchase was allowed in 1980.

How many stars the development attracted is open to question. It seems that most visiting actors preferred luxury hotels in central London, and being driven to and from Ealing Studios. Film crew did stay here, however.

The clubhouse featured two full-sized billiard tables, a grand piano and writing desks stocked with Ealing Village-headed notepaper. Lunch, morning coffee and afternoon tea were served by liveried staff in the lounge. In the years before television, there were weekly events in the clubhouse, and a Christmas variety show performed by residents.

One celebrity, who lived here as a teenager, was Pearl Carr of 1950s singing duo Pearl Carr and Teddy Johnson.

Waite and Rose

The site of the first branch of Waitrose, then known as Waite, Rose and Taylor, is marked with a plaque set into the pavement at 263 High Street, Acton.

The shop, owned by Wallace Waite, Arthur Rose and David Taylor, opened in 1904. When Taylor left the business in 1908, the remaining partners combined their surnames and re-christened the store Waitrose. They opened further branches in the area, including at 190 Acton Lane, 65 Churchfield Road West, and 132 Bollo Bridge Road. The firm left Acton in 1925.

Wallace Waite pioneered the sourcing of food from around the British Empire, and his window displays promoting, for example, tinned Canadian honey, soups, fruit, salmon and veg won awards.

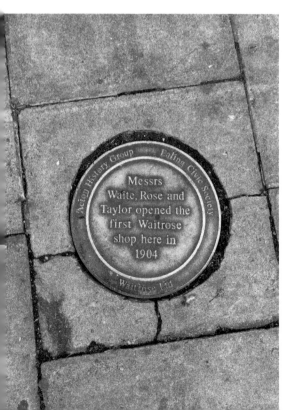

A pavement plaque in Acton High Street marks the site of the first Waitrose grocery store.

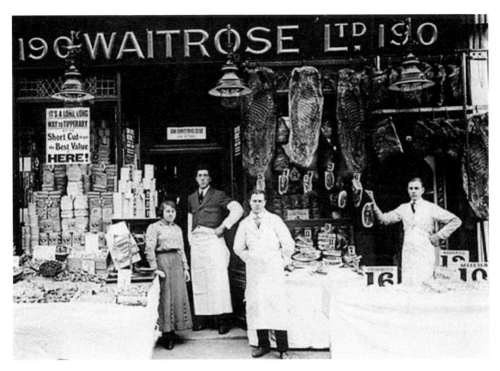

The Waitrose store at 190 Acton Lane.

He was one of the first retailers to understand the power of brands and logos in promoting his business, and often had ideas for new product lines that he tried out on his family over Sunday lunch. Brands such as Sunny Brook and Round Tower sultanas became well known in the 1930s. Wallace Waite was awarded an MBE, and died in 1971.

Waller Bridge, Phoebe

The actor and writer best known for TV series *Fleabag* and *Killing Eve*, and for her script work on the 2021 Bond movie *No Time To Die*, was brought up in Ealing.

Phoebe, born 1985, attended St Augustine's Priory in Hillcrest Road, W5. In *Killing Eve*, title character Eve Polastri lives in Ealing with her Polish husband, Niko.

Warncliffe Viaduct

Queen Victoria took her first ever train journey from Slough to Paddington via Hanwell, where she was delighted by the view over Warncliffe Viaduct.

Queen Victoria loved the view from trains passing over Warncliffe Viaduct.

The 890-foot-long brick viaduct was built in 1836–37 between Hanwell and Southall to carry the Great Western Main Line railway across the Brent Valley, 66 feet above ground. It is named after James Mackenzie, Lord Wharncliffe, who steered the Great Western Railway Bill through Parliament. His coat of arms appears on the south side of the central pillar.

It was Grade I listed in 1949, one of the first structures to achieve this distinction. Its graceful appearance is due to the pleasing shape of the eight broad, semi-elliptical arches spanning 70 feet and rising 17 feet. The architectural historian Nicholas Pevsner said of it: 'Few viaducts have such architectural panache.' The piers are hollow, making ideal roosting sites for bats.

Whetnall, Edith

Dr Edith Whetnall (1910–65) was a world authority on deafness in children who founded an innovative hostel for them at 8 Castlebar Hill, W5, in 1953.

Dr Whetnall challenged the assumption that profoundly deaf children would never learn to speak. She had observed that some such children could, because their mothers had recognised their condition when they were very young and addressed it by speaking directly into their ears.

She developed the hypothesis that there were very few children born deaf who did not have some residual hearing. The technique she developed for treating

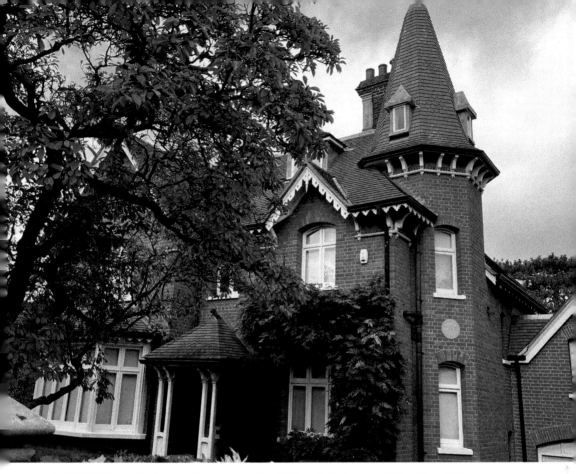

Dr Edith Whetnall pioneered treatment for childhood deafness at 8 Castlebar Hill.

them became known as auditory training, and her hypothesis was proved to be correct in all but a very few instances where disease was a factor. The development of hearing aids and cochlear implants made treatment much more straightforward.

At the hostel, which operated until 1993, mothers and their children could stay while hearing problems were assessed and parents given training to overcome their deafness. Later, older children were also treated.

In 1963 the Nuffield Hearing and Speech Centre, of which Edith was director, opened next door at 6 Castlebar Hill. It operated until 2006. By the time of her death, Dr Whetnall's clinics and treatment had become a model used around the world.

Willett, William

The man who invented Daylight Saving Time, known as British Summer Time in the UK, lived at 16 Avenue Crescent, Acton, in 1882–94. Willett (1856–1915) ran his family's building company, developing houses in Chelsea and elsewhere in London and the South East.

William Willett, inventor of Daylight Saving Time, lived at 16 Avenue Crescent, Acton.

He became aware of what he saw as wasted daylight hours when, out early one summer morning, he noticed that many curtains were still drawn. Determined to stop people missing what he considered the best part of the day, he wrote a pamphlet, *The Waste of Daylight*, promoting the idea, then considered eccentric, of moving the clocks forward in summer.

Perhaps because the system he advocated was complicated – he suggested moving clocks forward in four stages during April, at twenty minutes a time, and reversing the process in September – he did not live to see it adopted.

The First World War, and the need to conserve coal, saw the idea finally passed into law in 1916. Willett is great-great-grandfather of Coldplay's Chris Martin who, in 2002, wrote the song *Clocks* about his ancestor.

Winnie the Pooh

The model for the bear made famous by A. A. Milne's tales came from Ealing. The bear was one of thousands of identical Alpha teddies manufactured at the soft toy factory of J. K. Farnell and Co. Ltd, which stood where Twyford C of E High School is now, in Twyford Crescent, W3.

The one destined to become immortalised in *Winnie the Pooh* and subsequent volumes was bought at Harrods in 1921 by Daphne Milne, for her baby son Christopher Robin.

The factory, called the Alpha Works, burned down in 1934, was bombed in 1940, and closed in the 1960s, when Farnells ceased training. A green Ealing Civic Society plaque marks the spot.

Above left: An Alpha teddy like this one inspired the creation of Winnie the Pooh.

Above right: J. K. Farnell's soft toy factory made way for Twyford C of E High School.

Shirley Harrison, in her book *The Life and Times of the Real Winnie-the-Pooh*, tells how the Farnell family moved to The Elms, a large house now part of the school, in 1898 and built a factory alongside it for their expanding business.

Sadly, Pooh is now far from home, languishing in a glass case in the children's section of New York Library along with the models for other characters in the stories.

Shirley, who would like to see Winnie and friends return to their homeland, says the problem is that no one knows who owns the toys. She told *The Daily Telegraph*:

A. A. Milne just sent them over there, and he was awfully careless about it. He made no contact with the publishers about their return, so they just never came back. It's a bittersweet aspect of the whole story; the family were just fed up with it all. There was no attachment left for the animals at all by then.

Workhouse

From 1727, the parish workhouse stood opposite the lych gate to St Mary's Church in St Mary's Road, W5. Its fifty-five inmates spun wool and swept the streets. Numbers soon soared to 175, sleeping three to a bed. Most of the workhouse was demolished in 1839, but two now-pretty cottages at Nos 72–74 St Mary's Road remain.

Xelling

Ealing was known as Xelling in the twelfth century, when this spelling appears on a document on which Richard de Belmeis, Bishop of London, appropriates the 'tythes of Xelling' to provide a salary for the master of St Paul's school.

It was also known as Zealing and Yelnge before the present spelling was adopted in the seventeenth century. In 1638, tax collectors reported struggling to gain revenue from 'Ealing alias Zealing' because so many residents had fled to avoid taxation including the hated Ship Money Tax, levied to raise funds to build warships.

Yeames, William

The frescoes in the chancel of St Mary's Church, Hanwell, are by the Victorian artist William Yeames, most famous for his sentimental painting *When Did You Last See Your Father?*

Yeames (1835–1918), who lived at No. 8 Campbell Road, Hanwell, from 1894 to 1912, was a churchwarden at St Mary's.

When Did You Last See Your Father? depicts the young son of a wanted Royalist soldier being interrogated by Parliamentarians during the English Civil War. Yeames specialised in historical narrative paintings in which the viewer can discover a story through a close study of the scene presented.

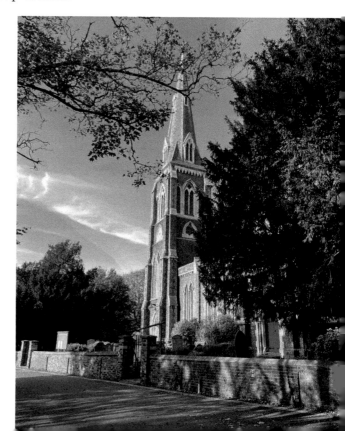

Victorian artist William Yeames painted frescoes at St Mary's Hanwell.

Zoo

Hanwell Zoo in Brent Lodge Park, W7, known locally as the Bunny Park, houses over forty species including meerkats, capybaras (the world's largest rodent), flamingos, cranes and Mandarin ducks.

The zoo carries out valuable conservation work, and in 2021 welcomed a troop of black-and-white ruffed lemurs. The species, endemic to Madagascar, is critically endangered and at risk of extinction.

The lemur enclosure is dedicated to local resident, weather forecaster and artist Tomasz Schafernaker in recognition of his support for the Bunny Park. Tomasz donated the £1,200 proceeds from the sale of his painting of a kingfisher to the zoo.

First licensed as a zoo in 1975, it also houses pygmy goats, kunekune pigs, tamarin monkeys, alpacas and porcupine. It has a reptile house and aquarium.

Pink flamingos at Hanwell Zoo.

Bibliography

ActonW3, *Churchfield Road's Tony Antoniou of Classix speaks out* http://www.actonw3.com/default.asp?section=info&page=conclassix01.*htm*

Anonymous http://www.visitsouthall.co.uk

Anonymous, *Acton's Impetuous Edwardian Stuntman* https://ealingnewsextra.co.uk/history/actons-impetuous-edwardian-stuntman/

Anonymous, *Billy Smart* http://www.circopedia.org/Billy_Smart

Anonymous, *British History Online* www.british-history.ac.uk

Anonymous, *Northolt Park Racecourse* https://northoltparkracecourse.wordpress.com/

Anonymous, *The Woolf's Strike* https://tuc150.tuc.org.uk/stories/the-woolfs-strike/

Armour-Chélu, Jane, *The Delius Society Journal* (London: Delius Society, 2000)

AroundEaling.com *Did monks' ghosts haunt local church?* www.aroundealing.com/history/monks-ghosts-haunt-local-church/ Betjeman, John, *Middlesex* (London: John Murray, 2006)

AroundEaling.com, *Ealing's Strange Fair* https://www.aroundealing.com/history/ealings-strange-fair/

Blake, Mark, *Freddie Mercury Before He was Famous* https://markrblake.wordpress.com/2015/09/05/freddie-mercury-before-he-was-famous/

Cadogan, Mary, *Frank Richards: The Chap Behind The Chums* (London, Viking, 1988)

Canon, John, *Oxford Companion to British History* (Oxford: OUP, 2002)

Chaplin, Charlie, *Autobiography* (London: Penguin, 1964)

Chaudhary, Vivek, *How London's Southall became 'Little Punjab'* www.theguardian.com/cities/2018/apr/04/how-london-southall-became-little-punjab-

Cirtin, April, *Only Fools and Horses* https://www.mylondon.news/whats-on/only-fools-horses-what-like-18172546

Evans, Steve, *My Friend the North Korean Defector* https://www.bbc.co.uk/news/magazine-37098904

Faraday, Judy, *Waitrose Memory Store* https://waitrosememorystore.org.uk

Fitzmaurice, Paul, *Spencer Perceval* https://littleealinghistory.org.uk/node/87

Goodall, John, *Pitzhanger Manor: The Ealing villa that's the great John Soane's 'architectural self-portrait'* https://www.countrylife.co.uk/architecture/pitzhanger-manor-ealing-villa-thats-great-john-soanes-architectural-self-portrait-208359

Harrison, Shirley, *The Life and Times of the Real Winnie-the-Pooh* (London: Remember When, 2011)

Higginbottom, Peter, *Central London School District* http://www.workhouses.org.uk/CentralLondonSD/

Horse and Hound, *End of the Road for Southall Horse Market* https://www.horseandhound.co.uk/news/end-of-the-road-for-southall-horse-market-135996

Jerrold, Walter, *Highways and Byways of Middlesex* (London: Macmillan, 1909)

McEwan, Kate, *Ealing Walkabout* (London: Nick Wheatley Associates, 1983)

MyLondon News *Striker Peter Crouch recalls Ealing* https://www.mylondon.news/news/local-news/striker-peter-crouch-recalls-ealing-5984679

Neil, Andy; Kent, Matt, *Anyway Anyhow Anywhere: The Complete Chronicle of the Who* (London: Virgin, 2011)

Pevsner, N. B. L., *The buildings of England, London 3: North-West* (London: Yale University Press, 1991).

Richards, Keith, *Life* (London: W&N, 2011)

Stevenson, Graham, *Migrants & the TGWU* https://grahamstevenson.me.uk/2020/04/10/migrants-the-tgwu/

Wood, Ronnie, *Ronnie* (London: Pan, 2001)

Acknowledgements

Grateful thanks are extended to all those authors quoted in this book, and to the photographers who have made their work available under Creative Commons.

Every attempt has been made to seek permission for copyright material used. However, if we have inadvertently used copyright material without permission/acknowledgement we apologise and we will make the necessary correction at the first opportunity.